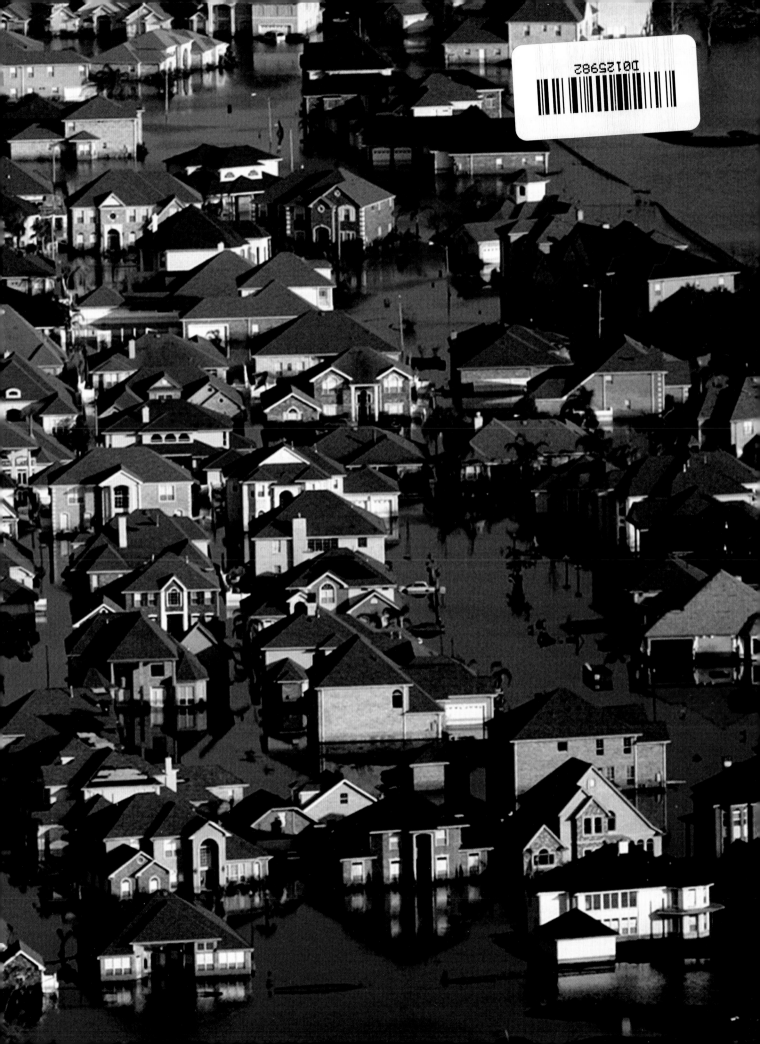

LIFE Books
Editor *Robert Sullivan*
Director of Photography *Barbara Baker Burrows*
Art Directors *Richard Baker, Anke Stohlmann*
Deputy Picture Editor *Christina Lieberman*
Writer-Reporter *Hildegard Anderson*
Copy Editors *Danielle Dowling* (Chief),
Barbara Gogan, Parlan McGaw
Consulting Picture Editors *Mimi Murphy* (Rome),
Tala Skari (Paris)

President *Andrew Blau*
Business Manager *Roger Adler*
Business Development Manager *Jeff Burak*

Time Inc. Home Entertainment
Publisher *Richard Fraiman*
General Manager *Steven Sandonato*
Executive Director, Marketing Services *Carol Pittard*
Director, Retail & Special Sales *Tom Mifsud*
Director, New Product Development *Peter Harper*
Assistant Director, Bookazine Marketing
Laura Adam
Assistant Publishing Director, Brand Marketing
Joy Butts
Associate Counsel *Helen Wan*
Book Production Manager *Suzanne Janso*
Design & Prepress Manager *Anne-Michelle Gallero*
Brand Manager *Roshni Patel*

Editorial Operations *Richard K. Prue (Director),
Brian Fellows (Manager), Keith Aurelio, Charlotte
Coco, John Goodman, Kevin Hart, Norma Jones,
Mert Kerimoglu, Rosalie Khan, Patricia Koh, Marco
Lau, Brian Mai, Po Fung Ng, Lorenzo Pace, Rudi Papiri,
Robert Pizaro, Barry Pribula, Clara Renauro, Donald
Schaedtler, Hia Tan, Vaune Trachtman, David Weiner*

Special thanks to *Christine Austin, Glenn Buonocore,
Jim Childs, Susan Chodakiewicz, Rose Cirrincione,
Jacqueline Fitzgerald, Lauren Hall, Jennifer Jacobs,
Brynn Joyce, Mona Li, Robert Marasco, Amy Migliaccio,
Brooke Reger, Dave Rozzelle, Ilene Schreider,
Adriana Tierno, Alex Voznesenskiy, Sydney Webber,
Jonathan White*

Published by LIFE Books
Time Inc.
1271 Avenue of the Americas
New York, NY 10020

ISBN 13: 978-1-60320-128-5
ISBN 10: 1-60320-128-9
Library of Congress Control Number: 2009936883

"LIFE" is a trademark of Time Inc.

We welcome your comments and suggestions
about LIFE Books. Please write to us at:
LIFE Books
Attention: Book Editors
PO Box 11016
Des Moines, IA 50336-1016

If you would like to order any of our hardcover
Collector's Edition books, please call us at
1-800-327-6388 (Monday through Friday,
7:00 a.m.–8:00 p.m., or Saturday, 7:00 a.m.–
6:00 p.m., Central Time).

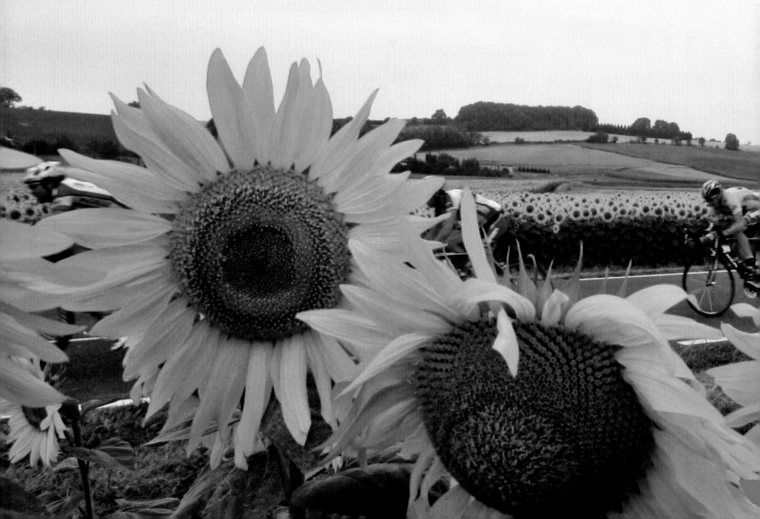

LIFE
2000–2009
THE DECADE THAT CHANGED THE WORLD

Page 1: Thomas E. Franklin (September 11, 2001)
Pages 2–3: John David Mercer/Mobile Register/Polaris (Hurricane Katrina)
These pages: Alessandro Travoti/AP (Lance Armstrong, in the yellow jersey, in the 2005 Tour de France)

THE DECADE THAT CHANGED THE WORLD

THERE HAVE BEEN DECADES IN American history that instantly conjure the one dominating story. Think of the 1920s, and you can hear the Jazz Age roar. Think of the '30s, and images of bread lines and the Dust Bowl immediately come to mind. With the 1940s, war thunders. If we consider the 1960s, there are various things—Vietnam, the civil rights movement, campus unrest—that combine to create an overarching impression of a society tearing itself apart.

With the first decade of the 21st century—the 10 years just now ending—we are confronted with a parade of major, disparate stories that made us stop and wonder, at regular intervals, *What is going on in this world?* When we thought yesterday's news made us immune to any further shock, we learned again and again that we were mistaken.

The planet today looks nothing like it did when fireworks exploded at midnight on December 31, 1999. Back then, most Americans felt they were living in a time of general prosperity and relative peace. Now we are at war in two different countries where thousands of U.S. troops have already been killed, and our economy is struggling to recover from a calamity not seen since the Great Depression, one that brought the world's financial system to the very brink of collapse. Back then, in 1999, most of us never dreamed we would be attacked on our own soil. Now, in 2009, we realize we have enemies who would attack us again tomorrow if given the chance. We live life in a different way and with different expectations than we did 10 years ago.

AFP/GETTY

How did we get from there to here? In turning the pages that follow, you will travel back in time and remember what it was like as you search for the answer.

Natural cataclysms as well as man-made ones shook our world. In 2004, one of the very biggest earthquakes in recorded history caused tsunamis that overwhelmed coastal communities in Southeast Asia, killing an unthinkable number of people. The next year, a hurricane of historic proportions ravaged a beloved American city. Three years after that, another huge earthquake struck in China, and the decade's death toll spiked again. Meanwhile, the issue of global warming loomed.

To be sure, there were headline-grabbing events during the decade that didn't pertain to death or destruction. A Roman Catholic pope made a pilgrimage to Jerusalem, for instance, and the U.S. elected an African American President. Meanwhile, acting as antidotes to the more horrific stories were the performances and antics of those in the arena and on the stage. Roger Federer and Michael Phelps achieved athletic success on an unprecedented level, while characters such as Harry Potter and Hannah Montana cast a spell over the kids. New toys were a distraction too: iPods and iPhones and BlackBerries and PlayStations and Wiis.

We will visit all of these events and topics in our pages, and then we will bid adieu to several friends who have departed throughout the decade—two beloved Presidents and a legendary senator, a Beatle and the King of Pop, celebrities who still had much to offer but were taken tragically young and legends who had lived good, long lives.

In assembling this book, LIFE's editors found themselves amazed anew at how many events of the past decade were not only momentous but truly earth-shattering. We think you'll be amazed as well.

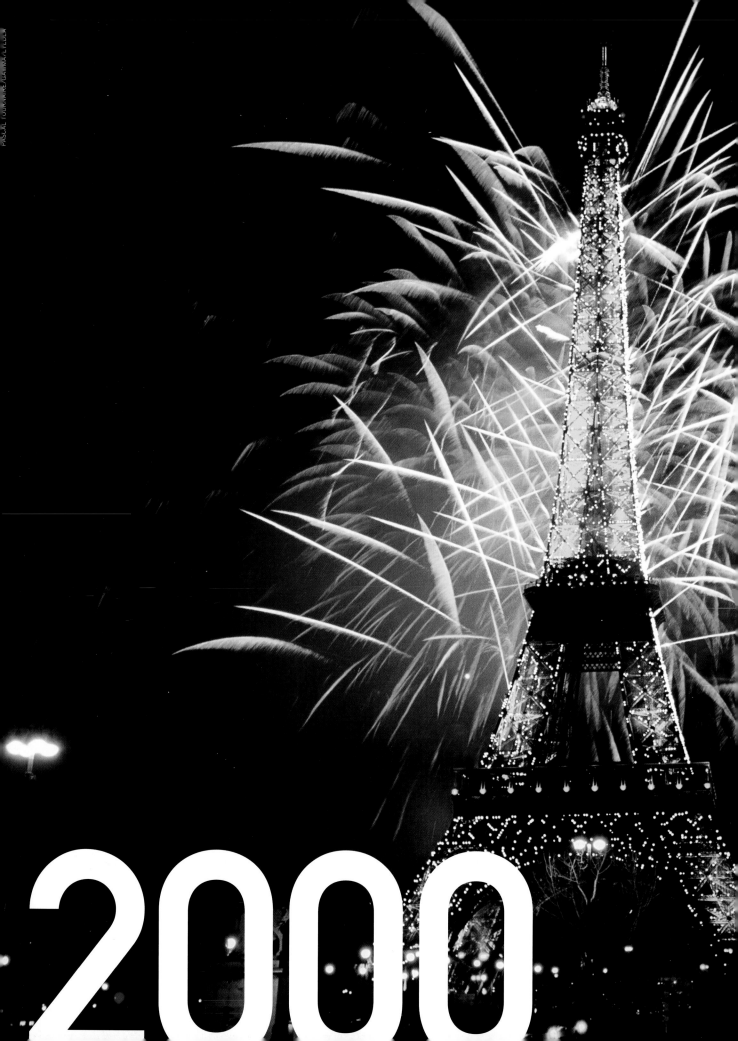

2000

IT IS STUNNING—even chilling—to think in retrospect that our largest communal concern as we entered what would become an altogether ferocious decade was whether a phenomenon known as Y2K would mess up our clocks and computers. As the calendar counted down the last days of the second millennium, the theory was that extant software wouldn't be able to handle the shift from 1999 to 2000. *Bank accounts will be frozen! Airplanes will plummet from the sky! Whole industries will collapse!* As it happened, not much happened. The glittering ball fell at midnight in Times Square, fireworks exploded around the globe (including, as we see here, in Paris), champagne toasts were raised, songs sung, dances danced, and on the first day of the new century, the world went about its business just as it had before.

At the time, everyone was looking at a brave new future fueled by technologies we could only imagine. The Internet was king as, in January, America Online announced it would buy Time Warner for $162 billion in the largest-ever corporate merger, and the Dow climbed to 11,722.98. This was the peak of what is now known as the dot-com bubble, though few people, if any, identified it as such at the time. By decade's end, the AOL–Time Warner deal would be seen as one of the largest-ever corporate fiascoes, and the burst bubble would be a factor in an economic free fall.

Clearly we were averting our eyes during this period, and not only from evidence of faux financial soundness. We in America were living in a cushy and complacent time, a time of great prosperity and relative peace, and so it was easy to look away. Among the items most of us did not see: From January 5 to January 8, in Kuala Lumpur, Malaysia, a summit meeting was held for higher-ups in a militant Islamist organization called al-Qaeda. Present at the confab were two men who, 20 months later, would be aboard an American Airlines jet as it took aim at one of a pair of skyscrapers in downtown New York City.

Events did occur in this other world that existed before 9/11, even if they now seem inconsequential by contrast. Finland elected its first female president in 2000, and Pope John Paul II became the first head of the Roman Catholic Church to make a pilgrimage to Israel. Vermont legalized civil unions for same-sex couples, and the billionth living person was born in India. A geomagnetic storm was caused by a solar flare in July, and Microsoft's Windows ME was released in September. The Summer Olympics came and went in Sydney, Australia, and the Yankees beat the Mets in a five-game Subway Series in Gotham. Perhaps most consequentially in the wider United States, the presidential election seemed to show George W. Bush and Al Gore in a dead heat, and it was left to the Supreme Court to resolve the rancorously contested matter in a still-controversial 5–4 decision.

In late 2000, many of us could not imagine anything more tumultuous than that unprecedented election.

We didn't know what tumultuous was.

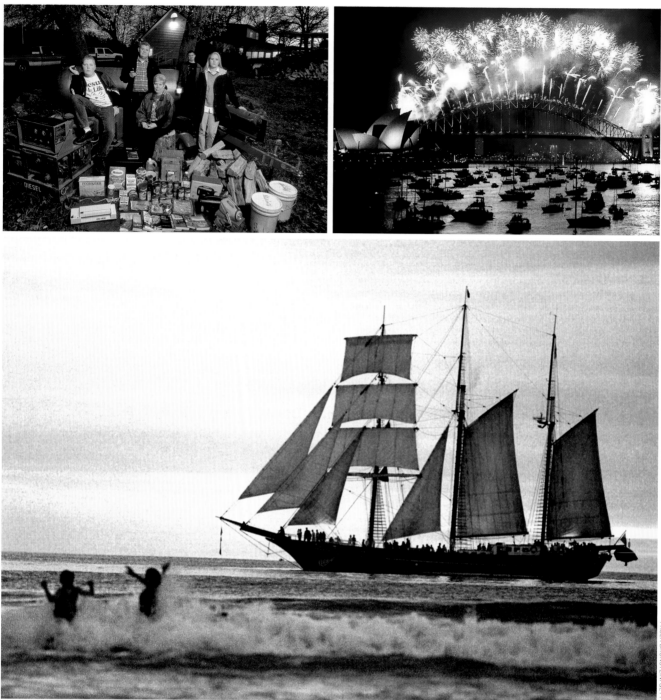

We said earlier that the new millennium began when the clock struck 12 on December 31, 1999, but in fact the Gregorian calendar insists that decades begin at the close of a year ending in zero, so Modern Man jumped the gun by 365 days. But we align ourselves in this book with Modern Man—his celebrations and his way of categorizing. On these pages, we see the lead-up, then the event itself. Top left: Jerry and Carolyn Head and their children, David, Lesley and Sarah, pose outside their home in Harrison, Arizona, with their Y2K stockpile—generator, wood, canned goods—in anticipation of the possible computer bug that will deliver us all to the apocalypse. The anticipated annum arrives first in the very far east (or west) and very much Down Under, and (top right) we see one of the travel-ing midnight's biggest blowouts in Sydney. Along with the Aussies, those who greet the future earliest are New Zealanders, who romp in the surf at dawn in Grisborne only hours later (above). Not far from that very sunny moment, in Rome at the Vatican, the pope enjoys fireworks (opposite), which begin for him a momentous year that not only marks 2,000 years since his savior's birth but also features his historic venture to the Holy Land.

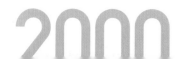

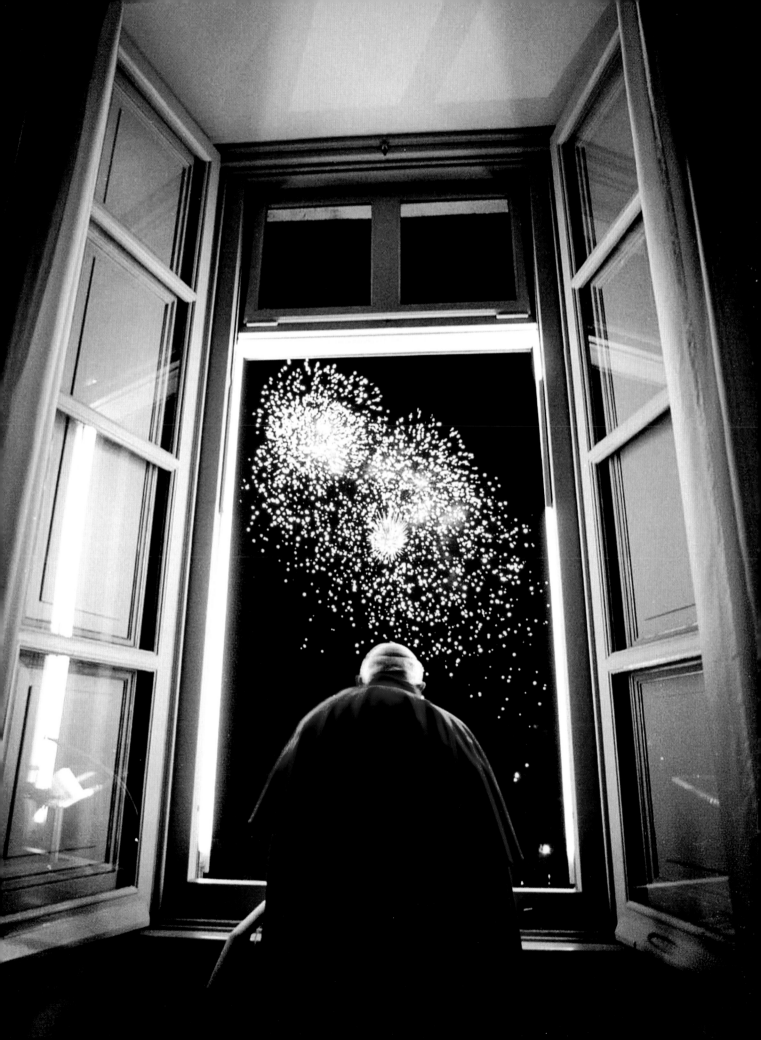

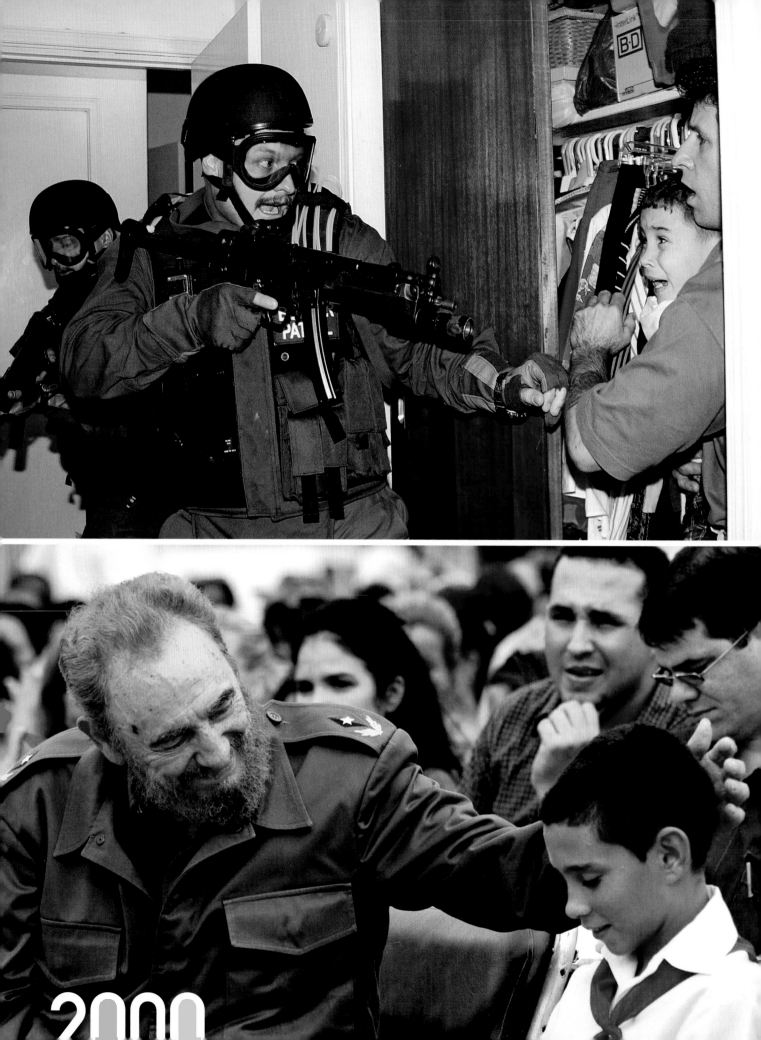

2000

The world celebrated the New Year, then was soon reminded that trouble and tumult lurked everywhere. Opposite, top: On April 22, six-year-old Elian Gonzalez screams while holding on to Donato Dalrymple, the fisherman who saved him when young Elian was a refugee at sea the previous November. The man holding the gun is a federal agent rushing in to take custody of the boy in the home of his relative in the Little Havana section of Miami. Elian would be sent back to Cuba, where President Fidel Castro strokes his head during a sixth-grade graduation ceremony in 2005 (opposite, bottom). Below: The USS Cole is attacked by a suicide bomber in a Yemeni port, and 17 are killed. Bottom: Defendants in the case from Yemen, Iraq and Somalia stand trial in Switzerland on charges relating to the attack and their involvement with al-Qaeda. The Cole incident would soon be seen as but a shot across the bow.

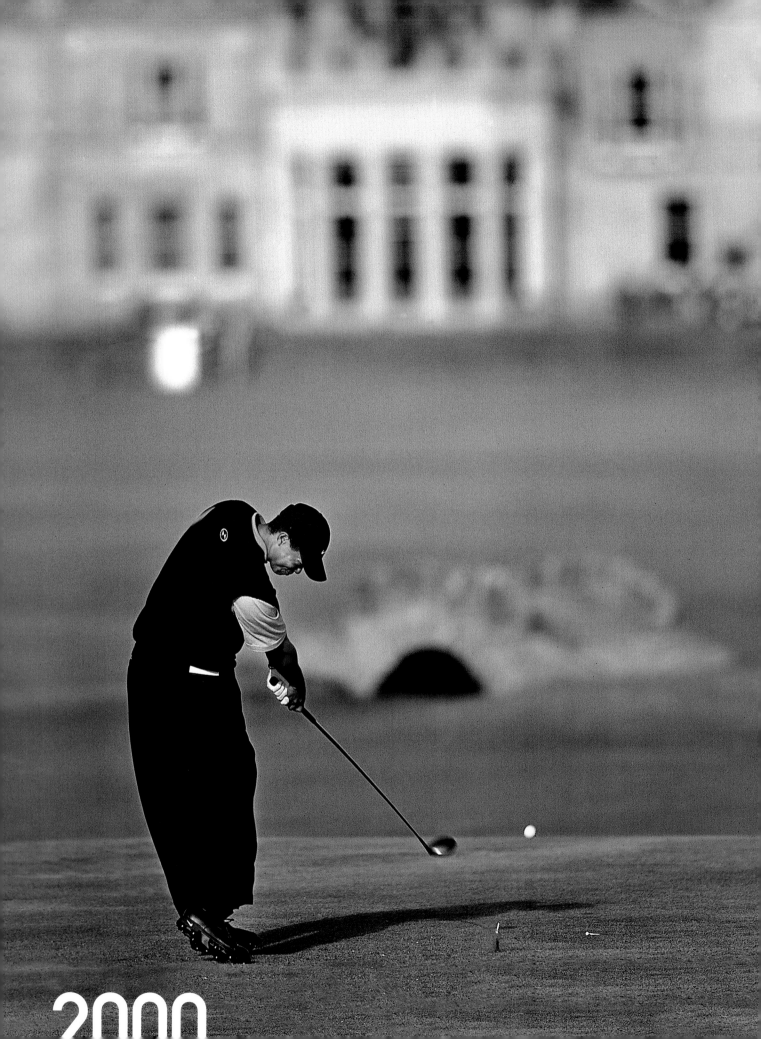

2000

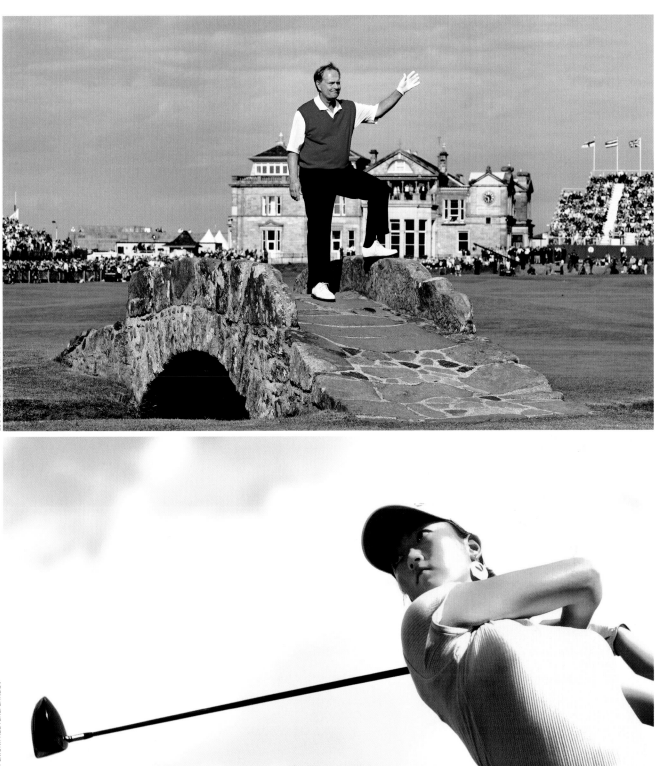

Life itself—the trials, the triumphs, the vicissitudes—could be seen metaphorically in the game of golf during this decade. Opposite: On July 22, 2000, Tiger Woods goes for the green across the Swilcan Bridge at St. Andrews, Scotland, the storied birthplace of golf, and in winning the British Open becomes the youngest ever to triumph in his sport's four major tournaments. His stated if audacious goal, even at the age of 24, is to break the career record of 18 major championships set by Jack Nicklaus, who, at 65, poignantly bids farewell to the majors in 2005 when the Open returns to St. A's another time (top). A "female Tiger" announces herself as well, when Michelle Wie qualifies for the U.S. Women's Amateur tournament in 2000 at age 10; she would win it three years later. By 2004, she attempts to compete against the men at the Sony Open in her native Hawaii (above), but by decade's end, she has yet to win a professional tournament against either gender. Tiger, 34, is by that point at 14 majors and counting. Life tests us, makes us older, perhaps wiser.

What a long, strange trip it was! The presidential election of 2000 was among the most acrimonious, uncivil, tight and bitterly contested in the history of the republic; it would be settled (or at least decided officially) only through litigation. Above, we see a Broward County Canvassing Board member in Florida inspecting a protested ballot to determine just whom the anonymous voter was trying to vote for. Opposite, top left: At the Miami-Dade County Government Center, a four-person team probes the hanging or dimpled chad. Top right: Testimony is presented graphically before the Palm Beach County Canvassing Board. Center left: Bush attorney Phil Beck cross-examines a statistician in Tallahassee. Center right: Media members in the White House Briefing Room watch Al Gore's concession speech after the Supreme Court steps in on December 12. Bottom: The President-elect appears more somber than joyful as he delivers his acceptance speech, which is monitored by his vice presidential teammate, Dick Cheney, in Vienna, Virginia.

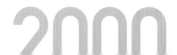

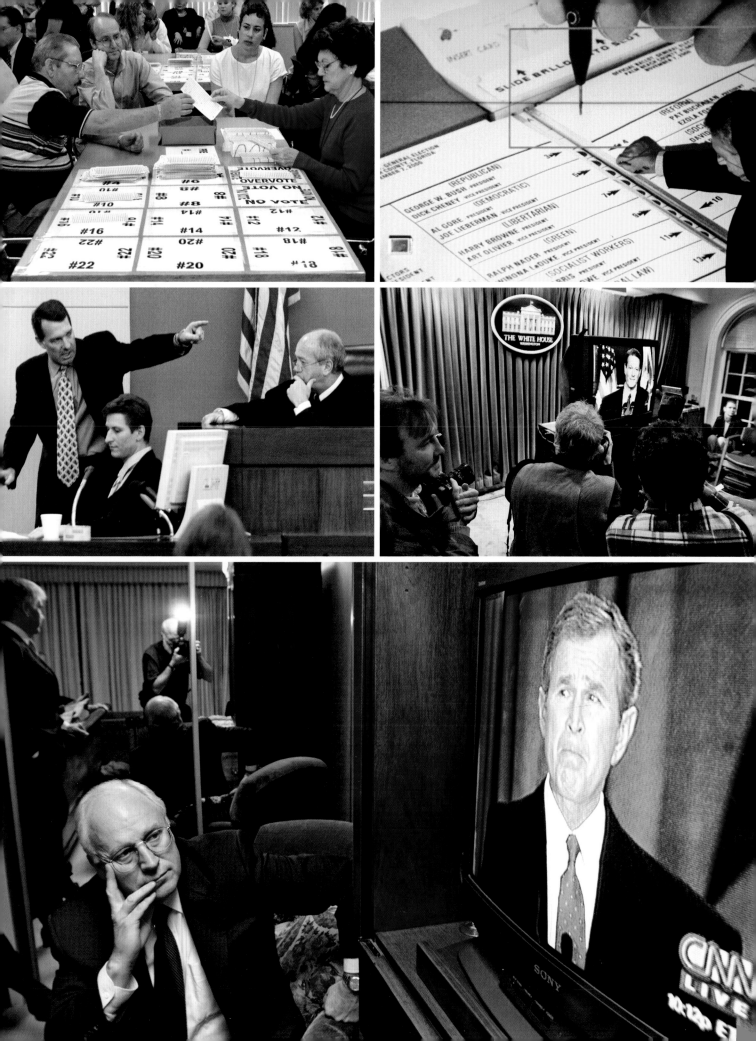

2001

EVENTS IN THE HISTORY of the United States are, of course, continuous and countless. Defining events are much more rare. The Shot Heard Round the World is fired in Lexington, Massachusetts, on April 19, 1775, and societal philosophies are put to paper in Philadelphia the following year. The Civil War is joined and, after unfathomable carnage and pain, settled. Manifest Destiny, for all its cruelties, expands the nation, and the Progressive Era emboldens it. The Great Depression is survived, and the attack on Pearl Harbor provokes a response that changes the whole world.

So, too, with the attacks of September 11, 2001—famously and forevermore known as 9/11. When hijacked commercial airliners were flown into the World Trade Center in lower Manhattan (seen here) and the Pentagon in Washington, D.C.—with yet a fourth commandeered airplane crashing in a rural Pennsylvania field—the nation was confronted with a moment of truth. Who did this? How will we respond? How does our new reality square with the world as we knew it only yesterday?

The shocking events of 9/11 would change and inform all that would follow in the decade—and, indeed, in decades to come.

What do you remember of 2001? That a January earthquake in El Salvador, Richter scale magnitude 7.6, killed more than 800, or that a later one that same month killed more than 12,000 in India? That Dale Earnhardt died in the last lap of the Daytona 500 the following month? That in March, *Gladiator* won Best Picture; that in April, the first space tourist went for a spin on Russia's *Soyuz TM-32* spacecraft; that in May, Silvio Berlusconi was elected Italy's leader? In June, President Bush signed into law his tax cuts, and in July, the first self-contained artificial heart was implanted in Robert Tools. Do we remember those events?

None of it. We remember none of it. The attacks of 9/11 overwhelmed all. A defining event.

Before October was out, we were at war in Afghanistan, and a new law, the USA Patriot Act, was on the books. In November, President Bush signed an executive order allowing military tribunals against foreigners suspected of terrorist activity. In December, Zacarias Moussaoui was indicted for his involvement in the planning of 9/11, and Richard Reid was arrested after trying to ignite a shoe bomb during a flight from Paris to Miami.

The country experienced a great upwelling not only of nationalistic pride but also of fear and vulnerability. Anthrax was arriving in the mail. How was this related to the attacks of 9/11? As it eventuated, it was in no way related. But back then, who knew?

The last weeks of 2001 were as confusing a time as the nation had experienced in its 225 years. As confusing. As depressing. As terrifying.

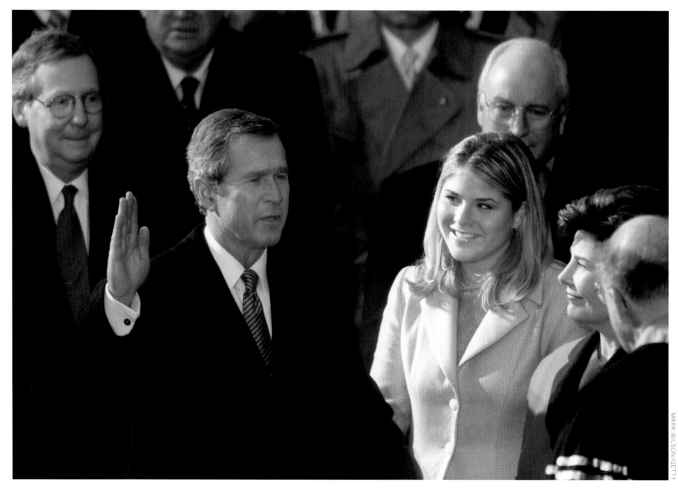

On January 20, George W. Bush is sworn in as the 43rd President of the United States of America, having won fewer popular votes than his rival but, once the contest in Florida had been decided by the courts, more of those cast by the Electoral College; his daughter Jenna looks on proudly. In his inaugural address, he promises to strive to unite a land divided: "Today, we affirm a new commitment . . . to principle with a concern for civility. A civil society demands from each of us goodwill and respect, fair dealing and forgiveness. Some seem to believe that our politics can afford to be petty because, in a time of peace, the stakes of our debates appear small. But the stakes for America are never small." True enough, and President Bush would not lead a country virulently divided for long, nor would he lead a country that was "in a time of peace." On a visit to the Emma E. Booker Elementary School in Sarasota, Florida, where he is reading to schoolchildren, he is told by adviser Andrew Card (opposite) that a second tower of the World Trade Center in New York City has been struck by an airplane. It is evident, suddenly, that America is under attack. And it is immediately clear that nothing is quite the same as it was only minutes before. In the aftermath of the terrorist act, the United States is perhaps as unified in its patriotism as it has been since World War II. And peace is again a goal rather than an everyday norm.

2001

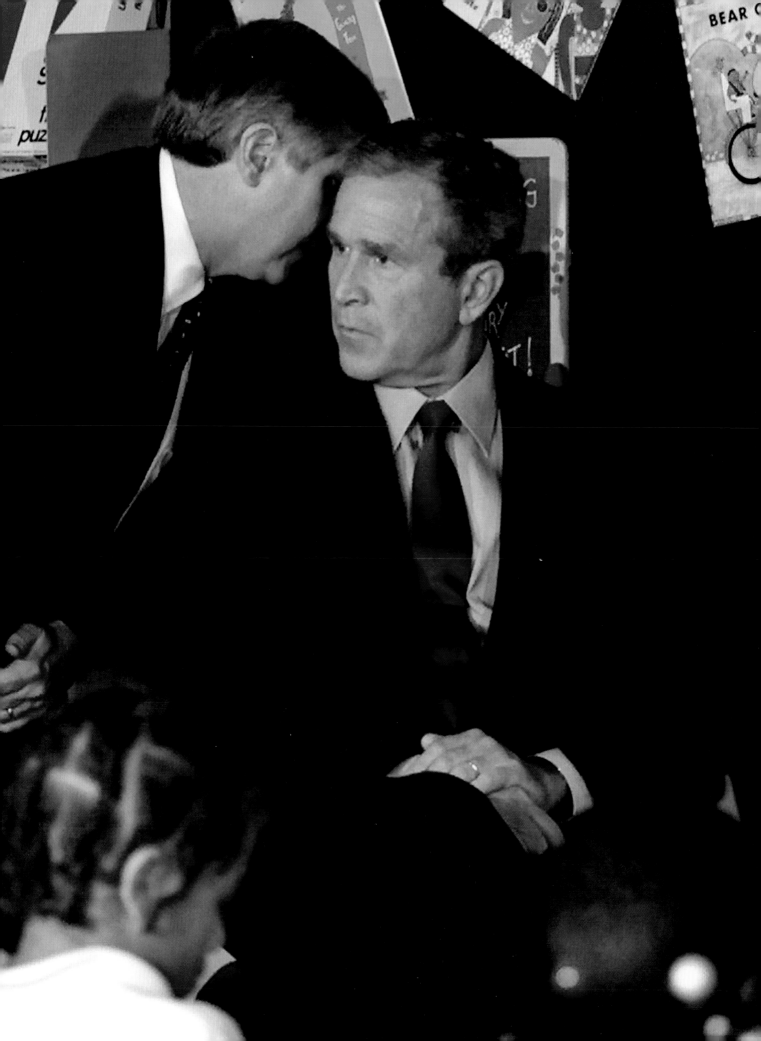

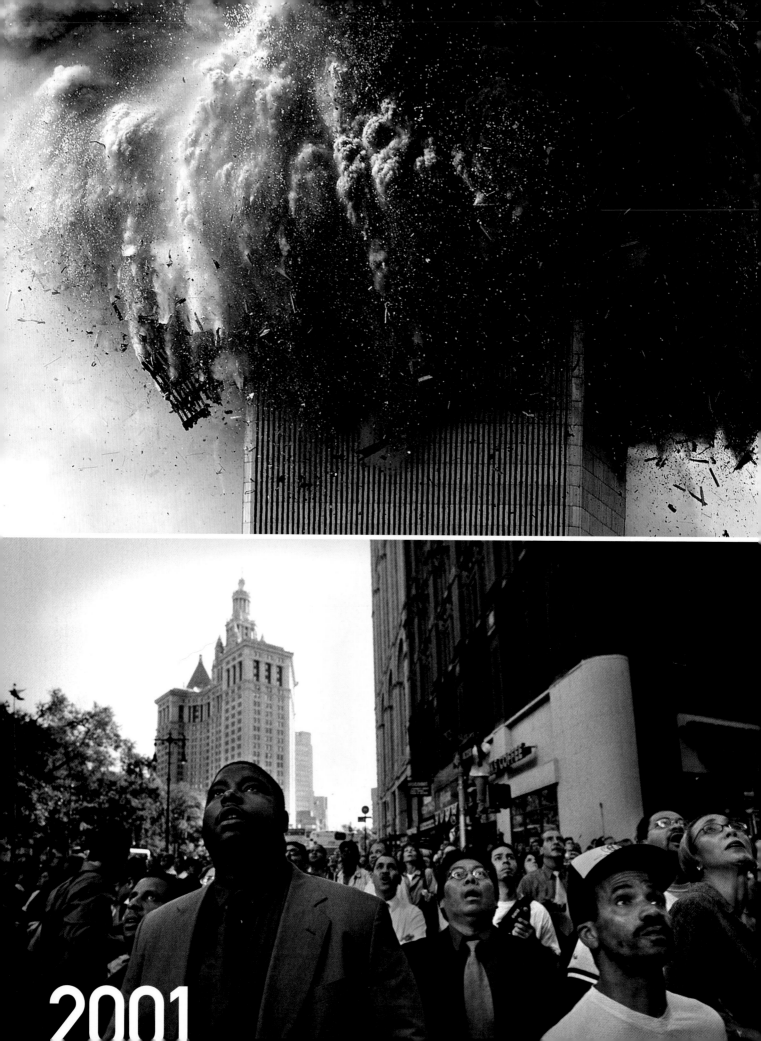

2001

As the President gave half his attention to the children at Booker Elementary School and more than half to the information he was receiving from Andrew Card, New York City was being assaulted by violent explosions, sudden death, leaping flames and then trailing smoke. Soon, it would be stunned further by the astonishing crumbling of the Twin Towers, the hallmark skyscrapers of the World Trade Center in lower Manhattan. Opposite: One World Trade Center begins to collapse (top), and people react. Below: Helicopters and fire trucks are deployed at the Pentagon, and a plume rises over rural Pennsylvania (bottom), near Shanksville, where a plane has crashed after its brave passengers challenged their hijackers, who had been headed for the nation's capital. They successfully foiled the hijackers' plans—at the cost of their own lives.

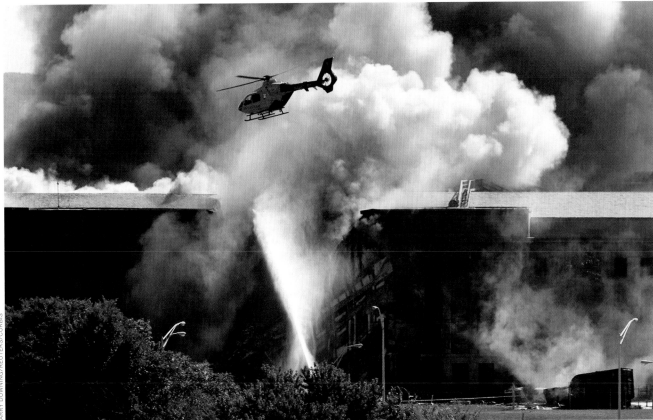

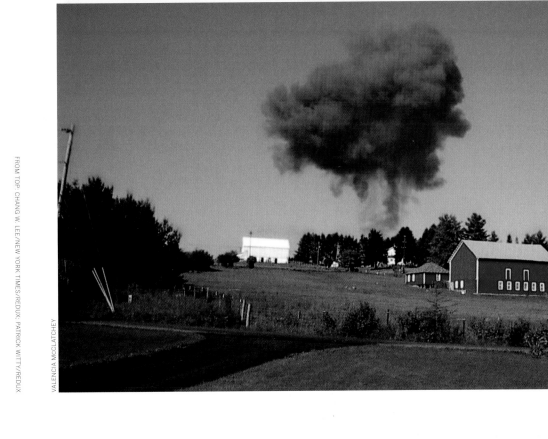

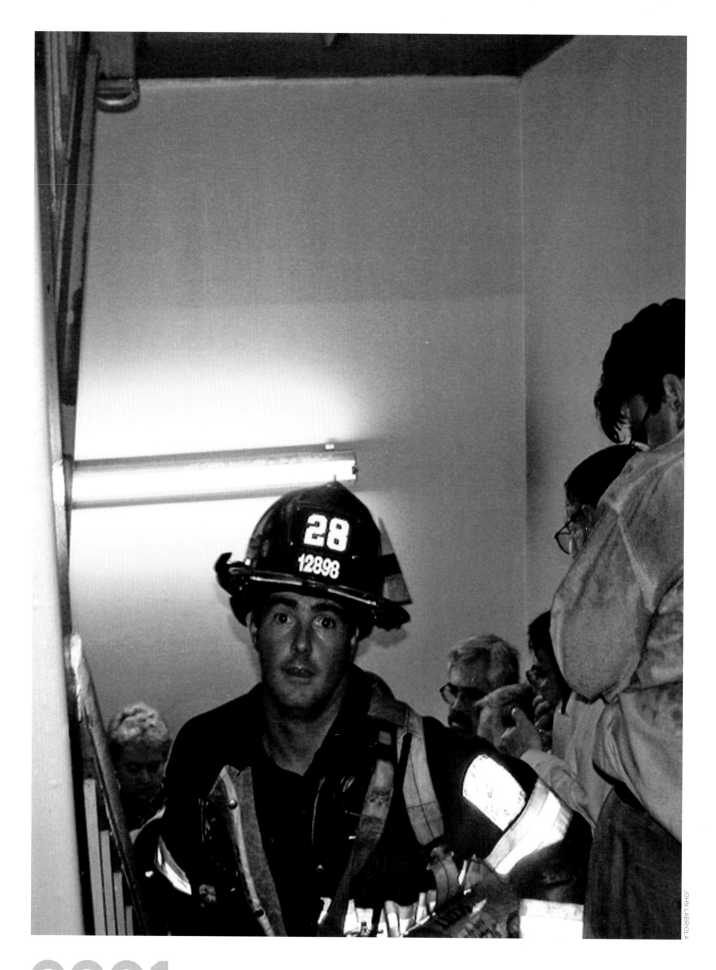

2001

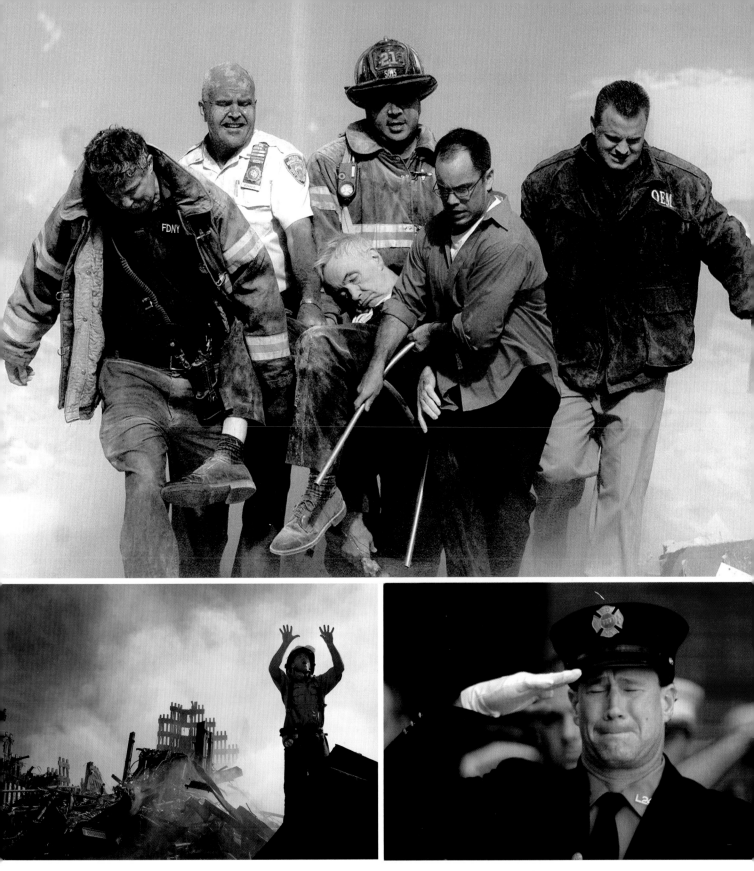

So many stories—tragic, heroic and both, often simultaneously—emerged from the smoke, debris and dust that thoroughly engulfed the lower end of New York City on 9/11. Opposite: John Labriola started taking pictures as he descended the stairwell during the evacuation of Tower One, and he captured this riveting image of Mike Kehoe, coming up to do his duty. (Kehoe would survive.) At top on this page is Father Mychal Judge, chaplain of the New York City Fire Department, who made his way downtown to console and counsel and then was himself killed. Above left: A firefighter calls out to a building still standing, "Is anyone there?" Above right: Another firefighter salutes at Father Judge's funeral service on September 15.

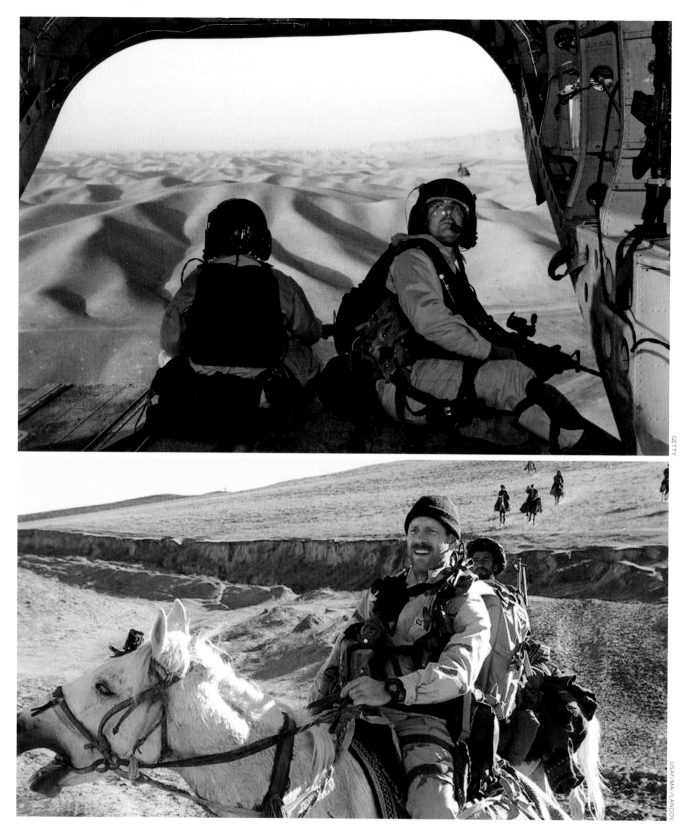

It was called Operation Enduring Freedom, and it was inaugurated in Afghanistan on October 7, less than a month after the 9/11 attacks and as soon as possible after the enemy had been identified. A principal target was the Taliban regime; the particular target was the leader of al-Qaeda, Osama bin Laden, who was, the assumption went, being given safe harbor by the Taliban. Top: U.S. special operations soldiers cross over by air from Tajikstan into Afghanistan on November 15. Above: Master Sergeant Bart Decker with the 720th Special Operations Group joins the first cavalry charge of the 21st century. Opposite, top: Anti-Taliban Afghan fighters watch U.S. bombings in the Tora Bora mountains on December 16. Opposite, bottom: Imprisoned Taliban fighters.

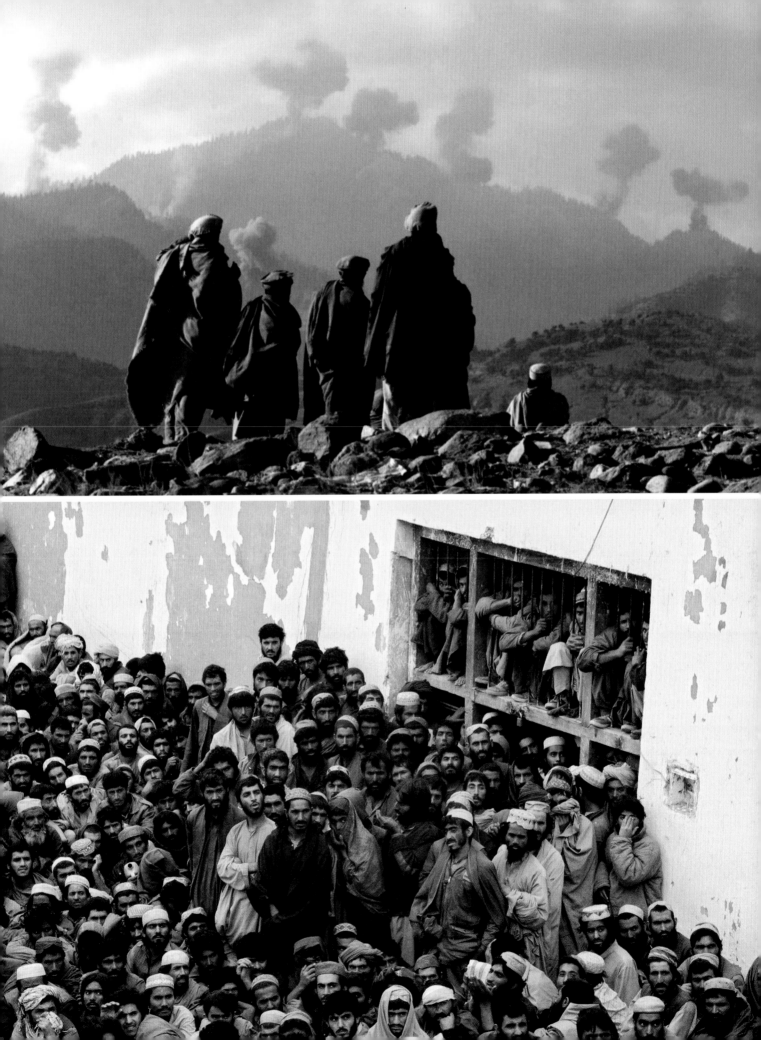

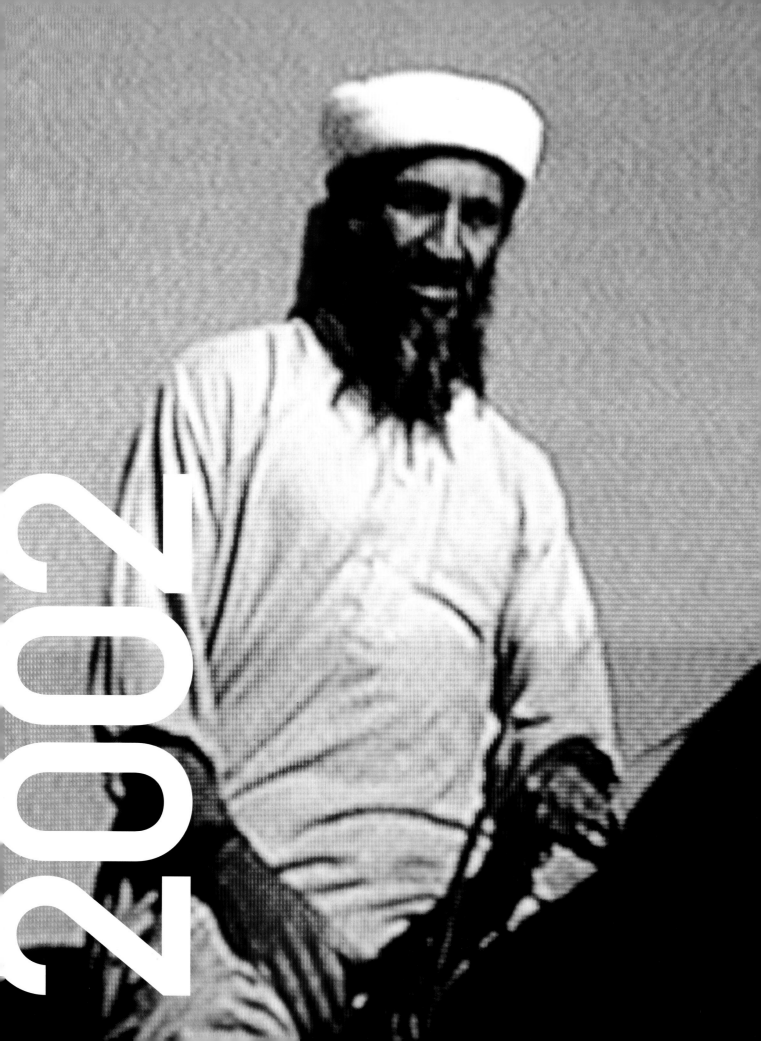

2002

AS AMERICANS came to understand more clearly just what had happened on September 11, the horrific events of that day assumed a face—that of Osama bin Laden, the radical Islamist who was head of the terrorist organization known as al-Qaeda. President Bush, at a time when he firmly believed that bin Laden would be caught (he was thought to be hiding in the mountains of Pakistan or Afghanistan), had used gunslinger talk about bringing the fugitive in "dead or alive." But as time went on and bin Laden remained at large, surfacing now and again to taunt his enemies in videos, the feeling grew that the West had an adversary to be reckoned with and the fight signified by 9/11 would not be over in a day or a year or a decade.

As we hunted this signature nemesis—a figure of villainy unmatched in the American mind-set since Hitler—we as a citizenry tried to return to day-to-day life in what was being called "the new normal." This proved difficult with reminders so constant. In January, Daniel Pearl, a reporter for *The Wall Street Journal,* was kidnapped while working the war beat in Pakistan; on February 1, he would be brutally murdered by his jihadist captors. In March, Operation Anaconda was launched, and 500 Taliban and al-Qaeda operatives were killed. Back home, unattended luggage was impounded at train and bus stations, and air travelers adjusted to long lines as shoes and belts and hats wended their way through X-ray machines.

Meantime, though, the New England Patriots won the first of three Super Bowl championships they would garner in the decade, and the Mars Odyssey discovered signs of large ice deposits on the Red Planet. We found that we were distracted by such news again; life was no longer 9/11, 24/7. Other disturbing headlines sometimes pushed the hunt for bin Laden below the fold of the daily newspaper. In Houston, Andrea Yates was sentenced to life for the drowning of her five children. Palestinian militants took over the Church of the Nativity in Bethlehem; after a 38-day siege by Israeli forces, the standoff came to a negotiated end. A jury in Birmingham, Alabama, convicted former Ku Klux Klan member Bobby Frank Cherry for the 1963 murder of four girls, bringing painful, overdue closure to the notorious Sixteenth Street Baptist Church bombing.

At midyear, England celebrated Queen Elizabeth II's Golden Jubilee with great pomp and circumstance. In France, during Bastille Day celebrations on July 14, President Jacques Chirac dodged an assassination attempt.

Autumn approached, and the national mood was somber on the anniversary of 9/11—somber but thankful that no further attack of consequence had occurred on American soil. We were moving forward, slowly, in the new normal—a world with different rules. On November 25, President Bush signed the Homeland Security Act. This was a telling measure of how substantially 9/11 had altered the landscape, as it constituted the very largest government reorganization in the United States since 1947, when the Department of Defense was created. Homeland Security's mission was to target this new kind of enemy: the terrorist.

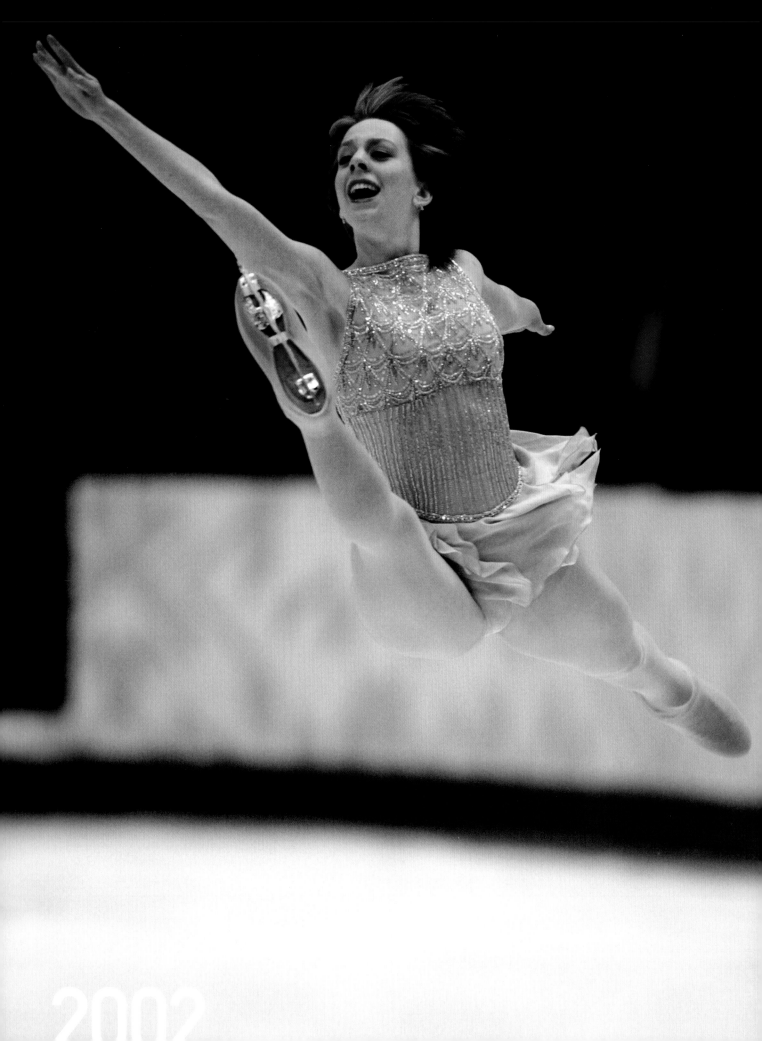
2002

The world desperately needed a little joy, and the Winter Olympics in Salt Lake City—the first Winter Games in the U.S. since those at Lake Placid, New York, in 1980—would provide it, despite the fact that a major controversy preceded the Opening Ceremonies because Salt Lake organizers had played (only too well) the hallowed Olympic game of doling out inducements to International Olympic Committee officials in order to be anointed as the host city. That was all water under the bridge once the athletes laced up their skates and buckled their boots. Opposite: In the high-glamour event of women's figure skating, Sarah Hughes from Long Island, New York, soared—and upset Michelle Kwan. The 2002 Games showcased all sorts of nouveau sports and reintroduced the daring skeleton sled races. Below: U.S. skier Joe Pack is flying upside down in the men's aerial freestyle-skiing competition. Bottom, from left: Apolo Anton Ohno celebrates after winning the gold in the 1,500-meter short-track speed-skating event, and Jamie Salé and David Pelletier of Canada finish their pair's free-skate program. They prevailed in a judging controversy and were awarded co–gold medals with the Russians, and thus the Games came full circle—beginning with a dust-up and ending with one.

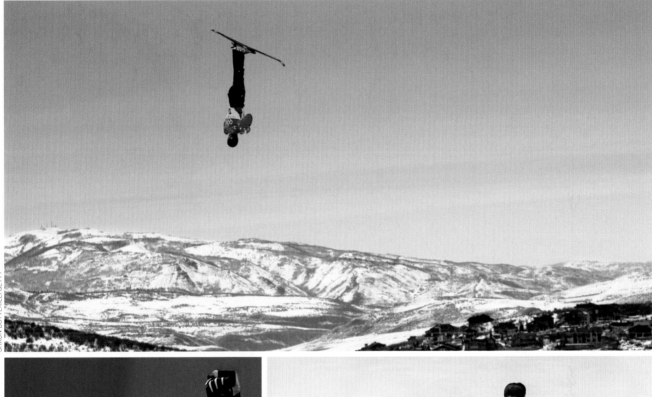

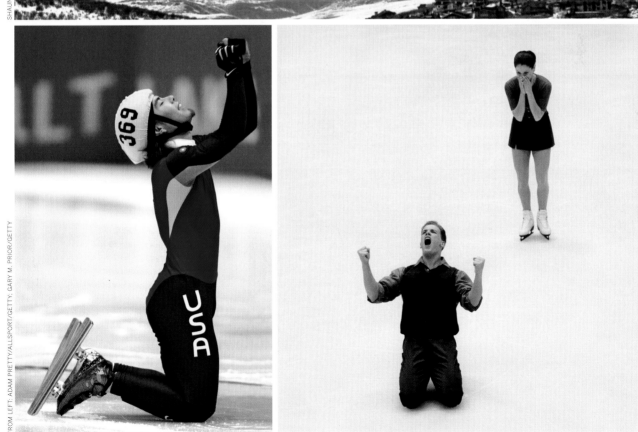

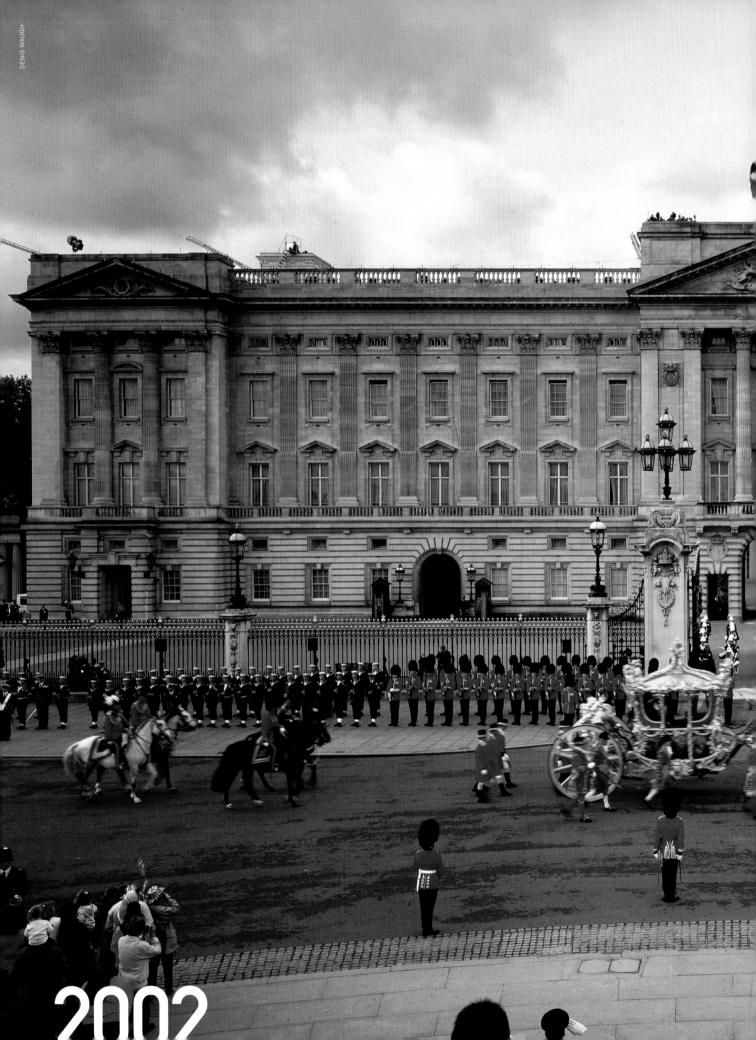

DENIS WAUGH

2002

British monarchs can no longer affect events as they once could back in the day, when a snap of their fingers or a wave of their hand could turn the world on its ear. But when Elizabeth II celebrated 50 years on the throne in June, Great Britain shouted huzzah, and others chorused. Predictions that the anniversary would be a nonstarter proved wrong, as considerable attention turned toward the queen. And why? Perhaps with our confusing world in such dire straits, celebrating the crown was a comforting embrace of order and tradition. For whatever reason, the jubilee brought smiles, never more so than on its peak day, June 3, when, at one p.m., more than 200 cities and towns across the United Kingdom played the Beatles' "All You Need Is Love" and followed that with the ringing of church bells. It is doubtful that the queen—here in a gold carriage leaving Buckingham Palace on her way to festivities the next day—knew the song or sang along, but she no doubt had a merrie olde time.

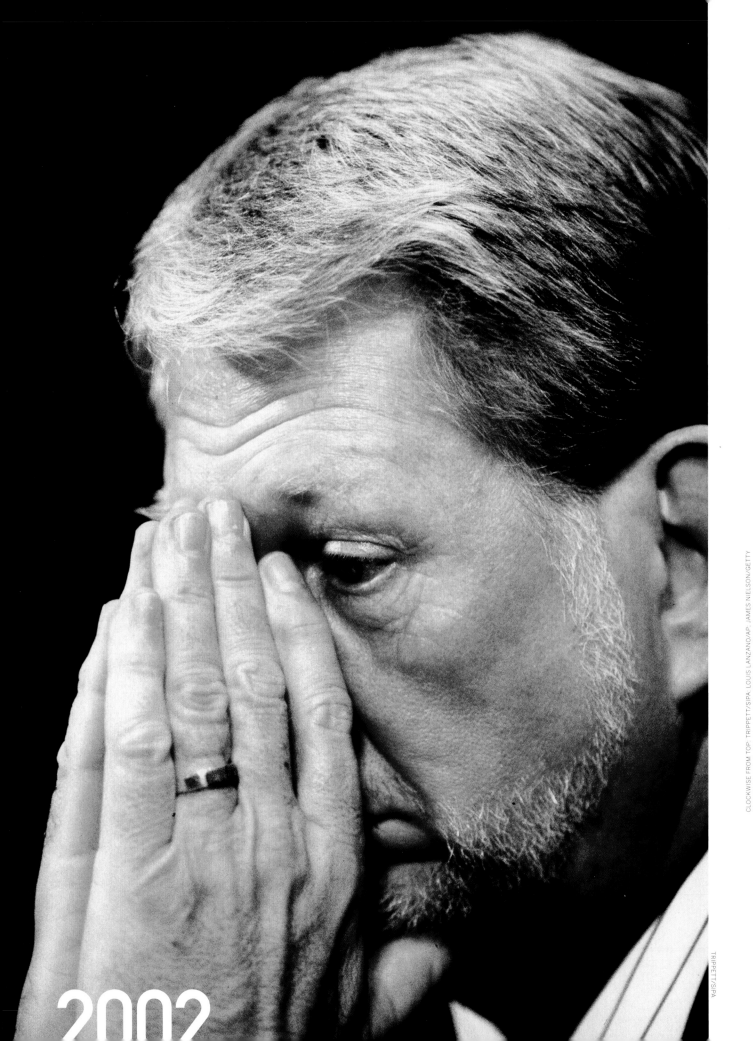

2002

CLOCKWISE FROM TOP: TRIPPETT/SIPA, LOUIS LANZANO/AP, JAMES NIELSON/GETTY

TRIPPETT/SIPA

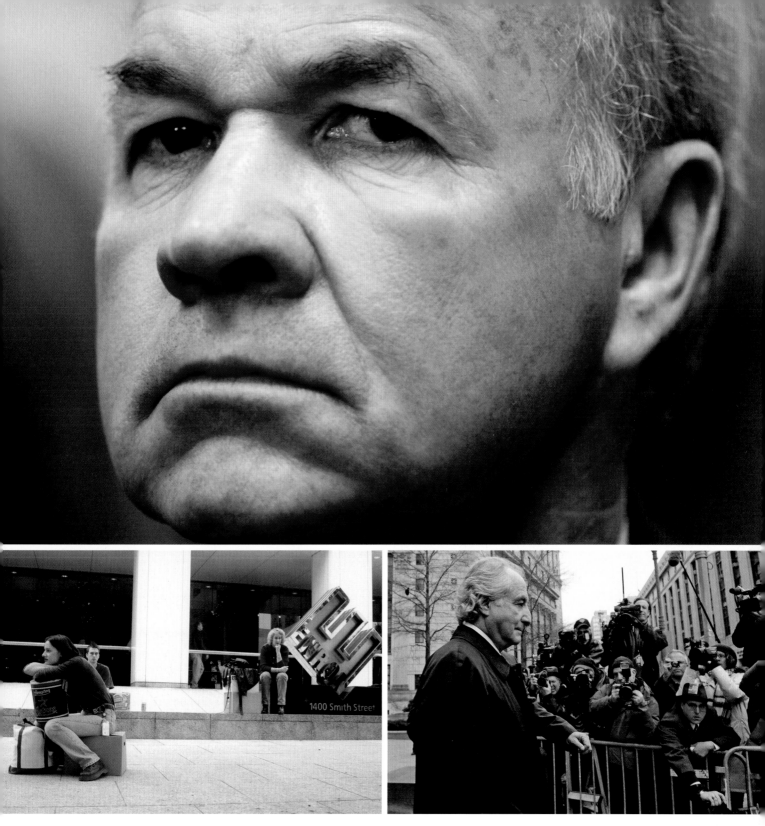

Oh, what tangled webs they weaved, when first (and second and third and fourth) they practiced to deceive. Throughout the decade, famous financiers proved to be nothing but mountebanks, propping up a false economy and stealing from those who trusted them. Opposite is Bernard Ebbers, the Canadian-born head of WorldCom, who was targeted in 2002 and convicted in 2005 of fraud and conspiracy regarding cooked books, which led to an $11 billion loss to investors. Above, at top, is Kenneth Lay, CEO and chairman of Enron, who resigned in January 2003, after the scandal in his company was revealed the previous year; he died in 2006, before serving time for crimes of which he had been convicted. His former employees are seen clearing out their offices after the company goes under (above left). To the right is Bernard Madoff, who exits Manhattan federal court on March 10, 2009, having made clear he will plead guilty to charges related to his Ponzi scheme—the biggest swindle since WorldCom's and one of the biggest ever in the history of the country. The economy needed no help in going bad in this decade, but it got plenty nonetheless.

2003

IN HINDSIGHT, so much about Iraq and the war that the U.S. entered into there in 2003 was misunderstood or misrepresented. It's still not clear at decade's end how much, if any, incorrect information was disseminated purposely or how much was due to a lack of military intelligence. But mistakes were made.

There can be little doubt that Saddam Hussein was a cruel, despotic ruler—a man responsible for the deaths of thousands upon thousands of innocents, many of his countrymen among them. But why did the U.S. feel it was its business to depose him? If you had asked many patriotic, attentive and approving Americans the reasons we were initiating military action in the spring of 2003, they might have answered that Hussein's regime had provoked a confrontation by stashing away an arsenal of weapons of mass destruction (*WMD* became a well-known acronym) or that in some way Iraq was linked to the 9/11 attacks, that it was in league with radical Islamists bent on anti-U.S. terrorism. Either rationale seemed a justification, and a majority of Congress backed President Bush when the invasion was launched—a backing that would return to haunt some legislators, most notably New York Senator Hillary Clinton, later in the decade. As it turned out, there were no WMDs and no links to al-Qaeda, but the war was on and the goal now was to win.

It seemed to be over quickly, which also proved to be an illusion, one that pointed to another grave mistake. In a new strategy for a major campaign, the U.S. military had gone in with a light, nimble, fast-moving assault force, which was fine when on the move (at left, U.S. Marines advance on the paramilitary Fedayeen on April 9) but was incapable of securing any kind of long-term stability once Baghdad had been taken.

We know all that now. We know much more—now, at decade's end—about what the perpetrators of 9/11 were thinking, about what went wrong in Iraq, about why we might have done well to concentrate on Afghanistan, about how we might have better handled Katrina, about the false prophets of the business world who should have been shunned and their critics who should have been heeded. The cliché is that hindsight is twenty-twenty, but the fact is that hindsight is revelatory and, it is hoped, instructive. Whether or not the toppling of Saddam Hussein was a good thing—and it can never be seen as anything but by the free world—we entered into this second Iraq war with questionable rationale. And in 2003, we were falling further into confusion regarding al-Qaeda, Osama bin Laden and much, much more. For instance, huge houses were being built, and everyone thought there was great prosperity throughout the land. At that moment, there seemed to be. Very soon, there would not be.

We think, sometimes, that modernity might better inform us or even protect us. In the information age—in a time of so much instant knowledge—how can we fail to discern the truth? How can we not see clearly? And yet . . .

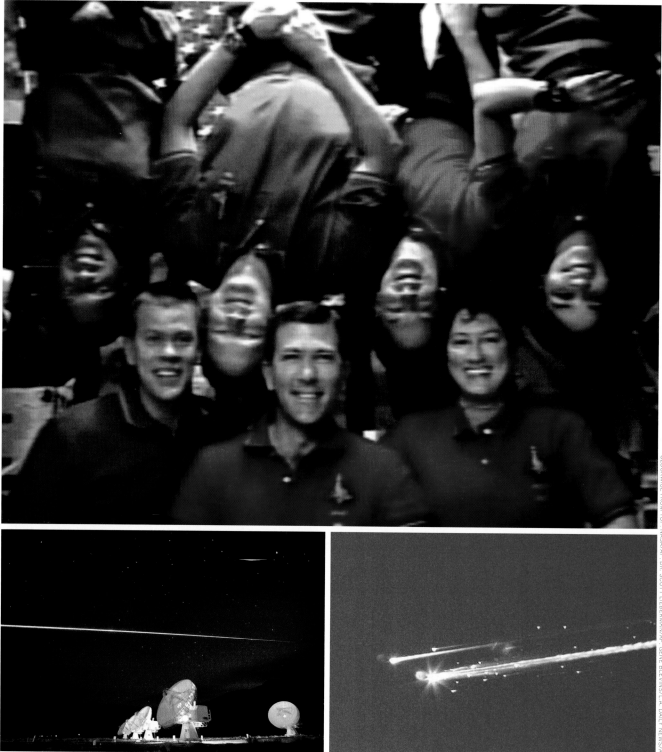

CLOCKWISE FROM TOP: NASA/AP; DR. SCOTT LIEBERMAN/AP; GENE BLEVINS/L.A. DAILY NEWS/AP

The space program had been visited by tragedy in the past, but there had been such a long string of successful missions—15 years of smooth sailing, 87 shuttle flights since the shocking explosion of Challenger shortly after liftoff—that people were freshly stunned when news came on February 1 that as Columbia prepared for its landing, it burst apart in midair. Lost were the crew, who had posed for a lighthearted—and weightless—portrait only days earlier (from left, Michael Anderson, William McCool, David Brown, Rick Husband, Ilan Ramon, Laurel Clark and Kalpana Chawla). At bottom left: Six minutes before its fateful end, the shuttle streaks over the Owens Valley Radio Observatory, north of Bishop, California. Bottom right: Debris is visible as Columbia disintegrates high in the morning sky over Tyler, Texas. Opposite: Later in the year, on October 24, another far less consequential failure is marked when fans of the Concorde, which had been unable to make a go of it in the marketplace, bid adieu to the supersonic passenger jet as this British Airways plane makes its last flight between New York and London.

JONATHAN BAINBRIDGE/REUTERS/CORBIS

2003

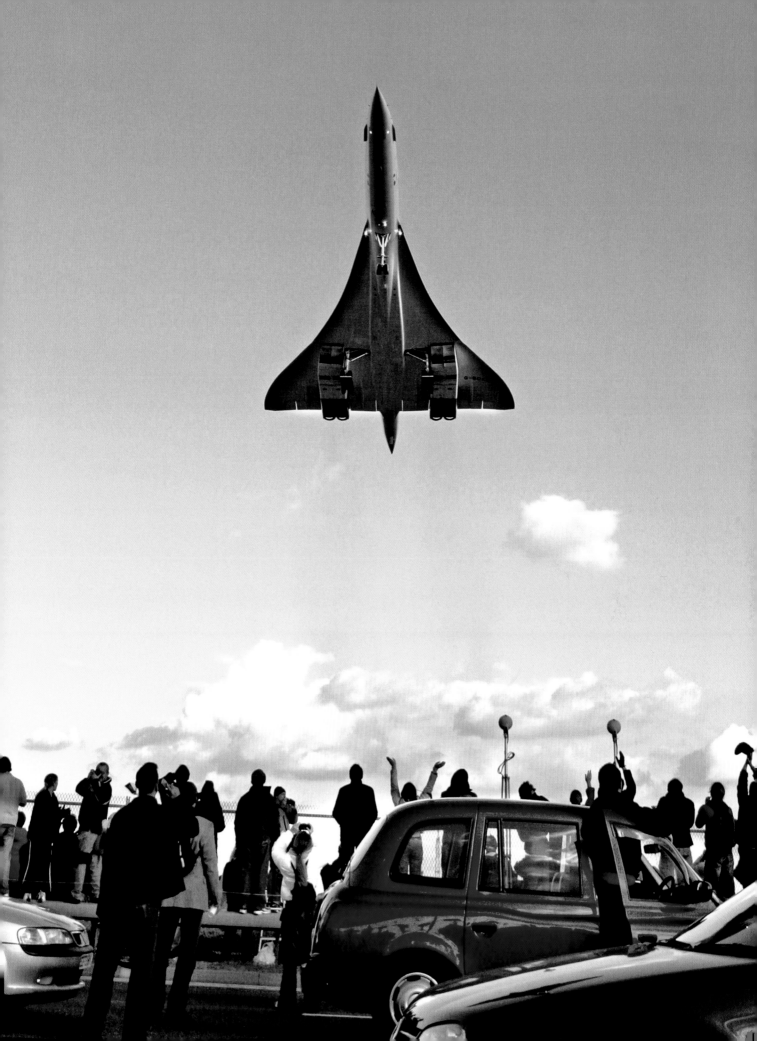

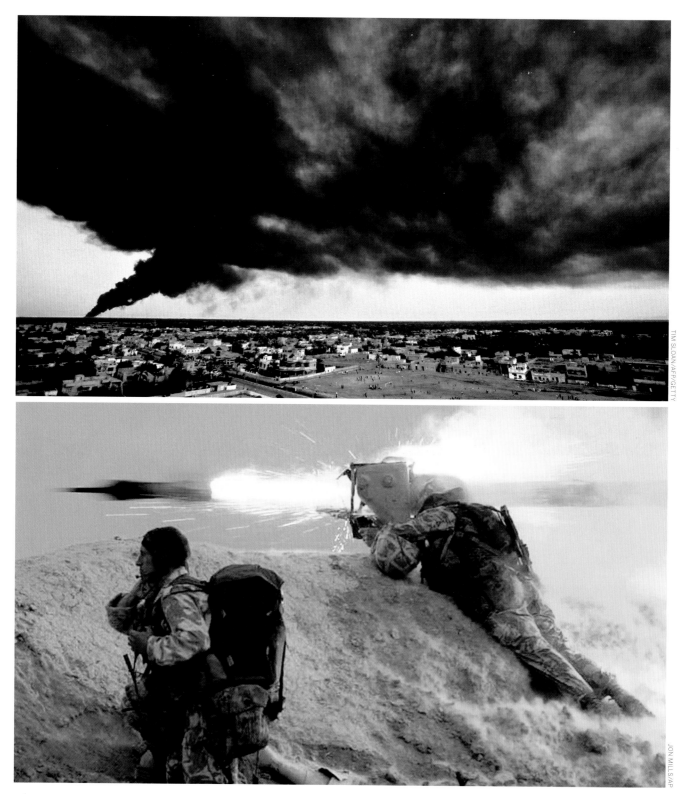

The world felt the drumbeat, and as the conflict drew near, President George W. Bush stood before 8,000 sailors in Jacksonville, Florida, and declared: "The terrorists brought this war to us, and now we're taking it back to them." In front of another crowd of sailors, this time on the USS Abraham Lincoln, he called the war with Iraq one battle in a larger and still-unfinished "war on terror," asserting that "we do not know the day of final victory, but we have seen the turning of the tide." On the ground, while the so-called shock-and-awe bombardment rained down upon Baghdad on March 19, Allied forces left their Kuwait staging areas and began their push to the northwest. A town taken early in the conflict, and secured thereafter largely by British forces, was Basra (top). Above: A British Royal Marine fires a wire-guided missile at an Iraqi position on the Al Faw Peninsula on March 21. Opposite: On March 29, a U.S. Marine medic near Rifa, in eastern Iraq, cradles a four-year-old girl. Her mother had been killed in front line cross fire, U.S. officers said.

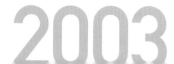

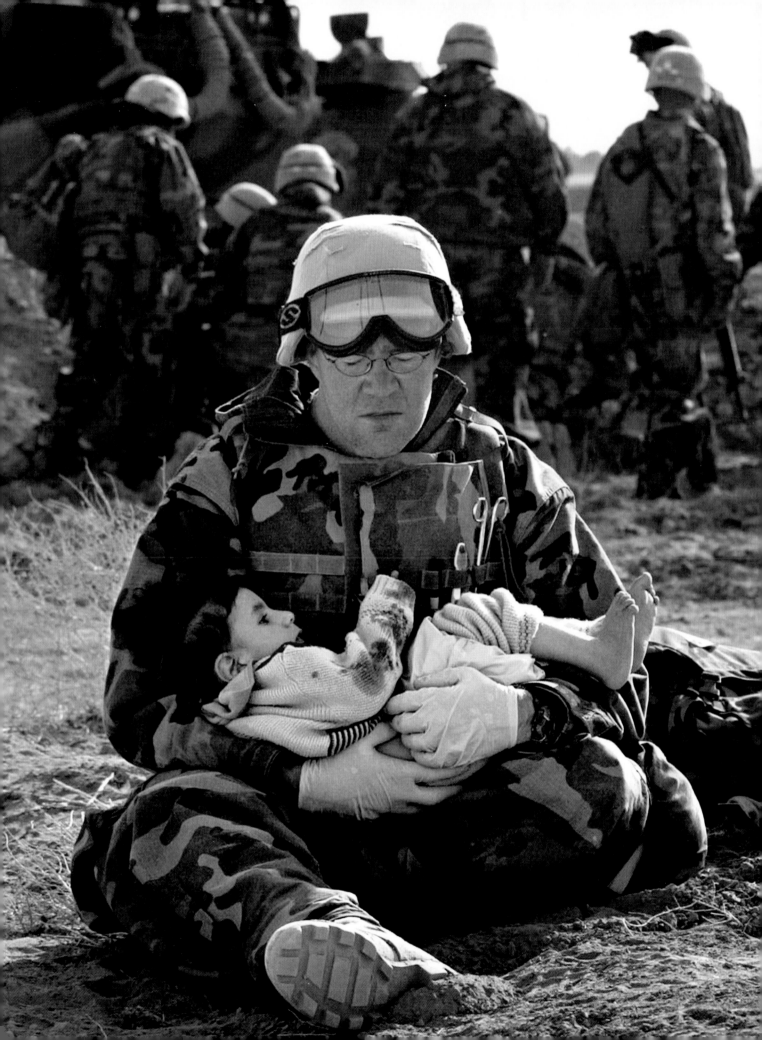

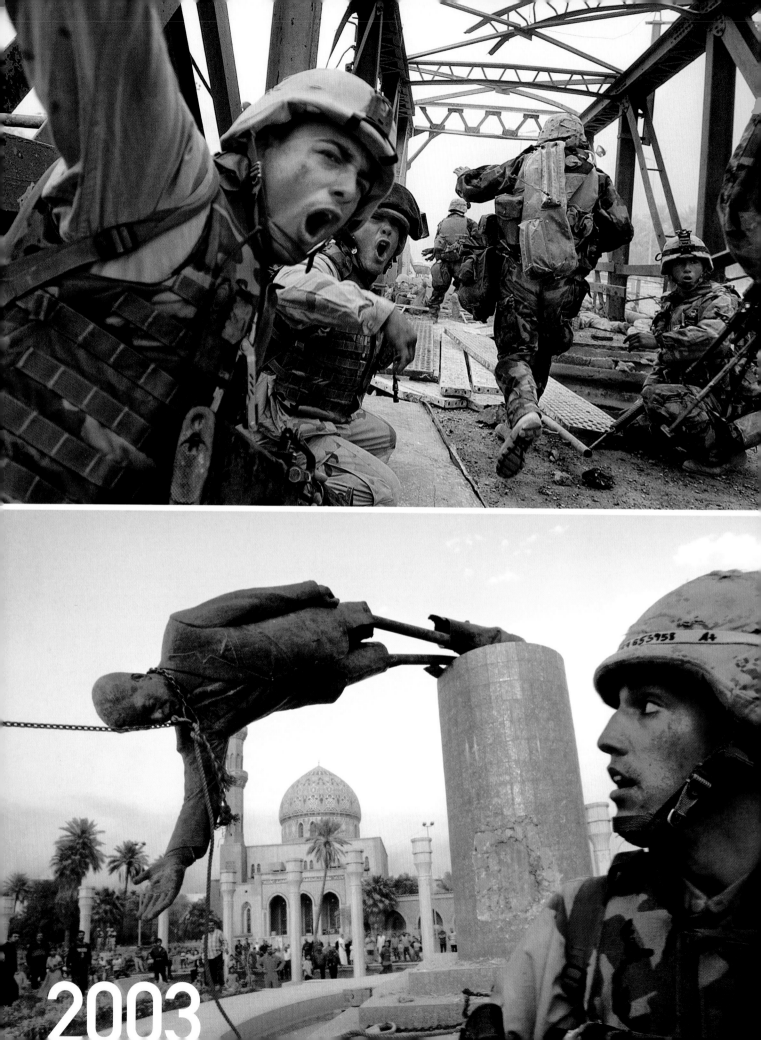

2003

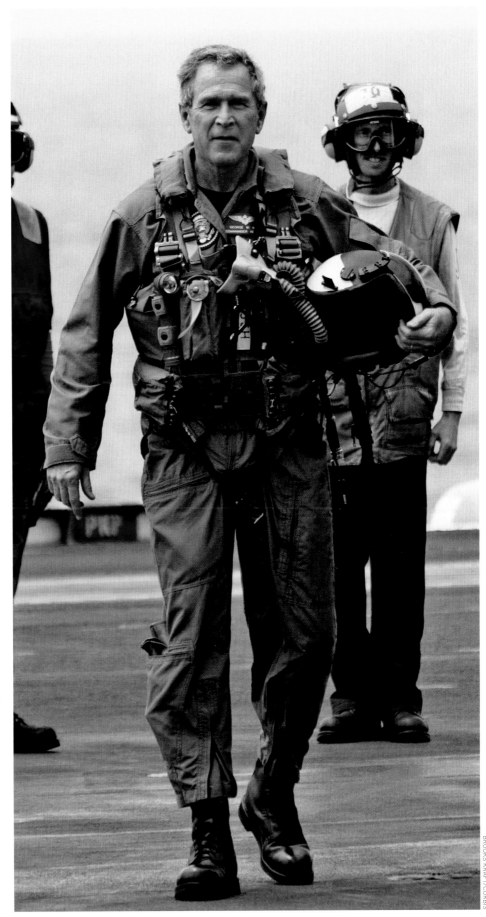

Opposite, top: As enemy fire crackles around them, members of the 3rd Battalion, 4th Marine Regiment exhort their comrades to charge across the Diyala Bridge. The span, which American soldiers dubbed the Baghdad Highway Bridge, crosses the Diyala River just southeast of Baghdad. The bridge wasn't strong enough to support tanks, so it had to be taken by foot. Two Marines were lost in the fighting, which took place on April 7. Opposite, bottom: Two days later, after American troops sweep into Baghdad virtually unopposed, an American soldier and the citizens of Baghdad are present for the fall of Saddam. The victory had been accomplished in just three weeks and with the loss of 137 American forces and 32 British—tragic but not nearly as costly as many had anticipated. (The Iraqi losses, both military and civilian, had been, of course, far worse.) On May 1, President Bush is back on the USS Abraham Lincoln, where he gives a speech announcing the end of major combat operations in Iraq, arriving aboard a Lockheed S-3 Viking and wearing a flight suit (right). By year's end, however, nearly 500 U.S. troops had been killed and by decade's end over 4,300; more than 95 percent of coalition casualties were incurred after the speech, which was delivered in front of a banner reading MISSION ACCOMPLISHED.

2003

On a Thursday afternoon, August 14, the largest electrical blackout in North American history left some 55 million Canadians and Americans in eight states in the Northeast and the Midwest without power. In scenes eerily reminiscent of September 11, New Yorkers straggled homeward across the Brooklyn Bridge or gathered in the Manhattan streets to ask what in the world was going on. In fact, anxiety was so acute after the juice went off, authorities rushed to assure that this wasn't another terrorist attack. (Later, blame would be placed on outdated transmission systems.) Fears assuaged, New Yorkers pitched in by hosting out-of-towners or serving as volunteer traffic cops. Some viewed

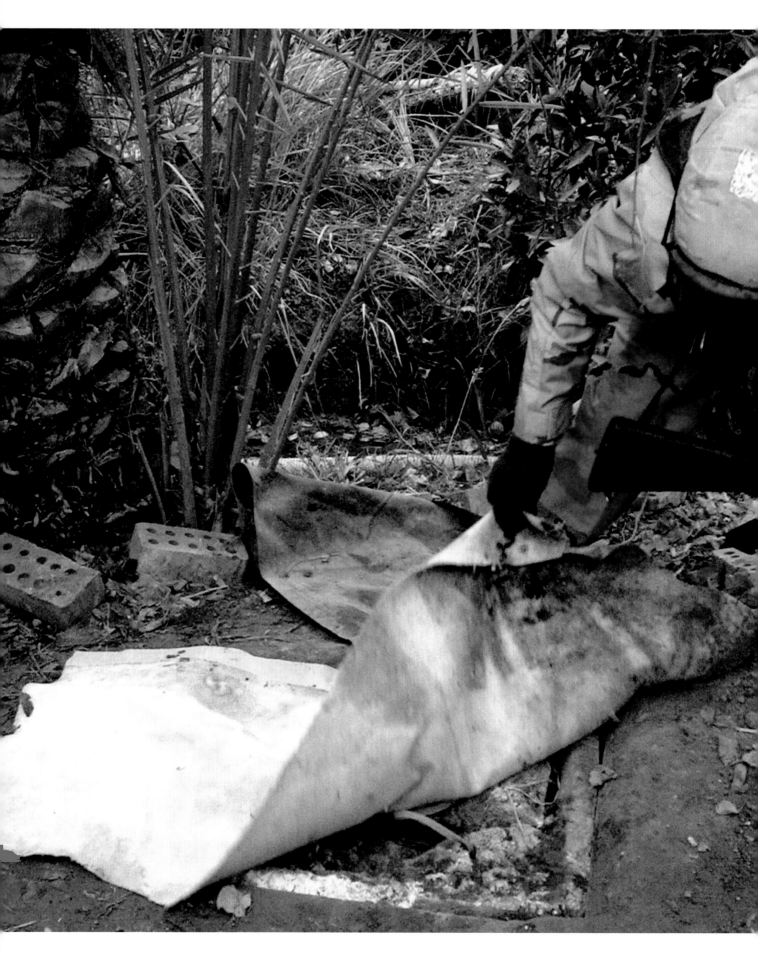

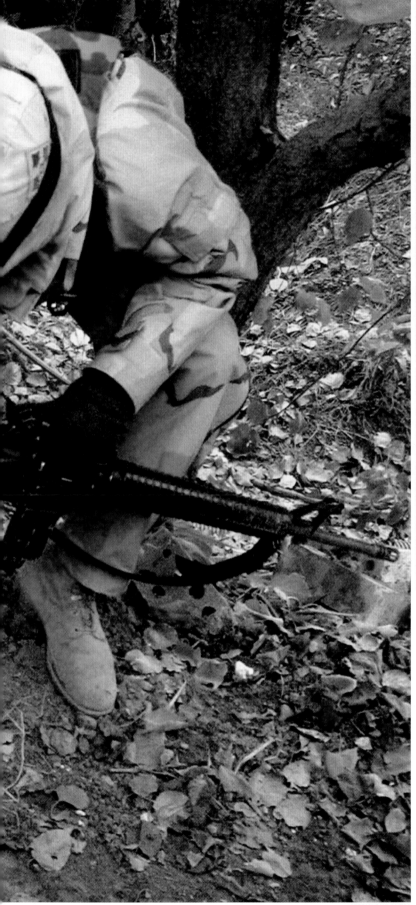

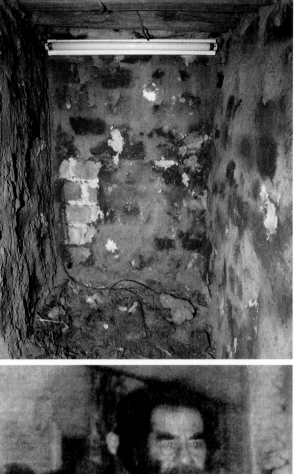

The year ended with the news that Saddam Hussein had been captured. On December 13, information extracted from Saddam's family members and former bodyguards led U.S. military officials to launch Operation Red Dawn in the town of ad-Dawr, not quite 10 miles from the deposed ruler's ancestral home of Tikrit. Six hundred soldiers from the Raider Brigade—the 1st Brigade Combat Team of the 4th Infantry Division—were deployed. Raids on the first two targeted areas came up empty. Then troops closed in on a small mud hut with a rude kitchen and another room where someone had apparently been sleeping. They searched farther and, in a subterranean hideout (left and top), found their quarry (above). "He was in the bottom of a hole with no way to fight back," said Major General Raymond Odierno. "He was caught like a rat." Saddam had a pistol but didn't resist arrest. Said Lieutenant General Ricardo Sanchez, commander of the U.S. forces, "He was a tired man and also a man resigned to his fate." That fate would lead to a trial and then an execution on December 30, 2006.

OF THE MOMENT

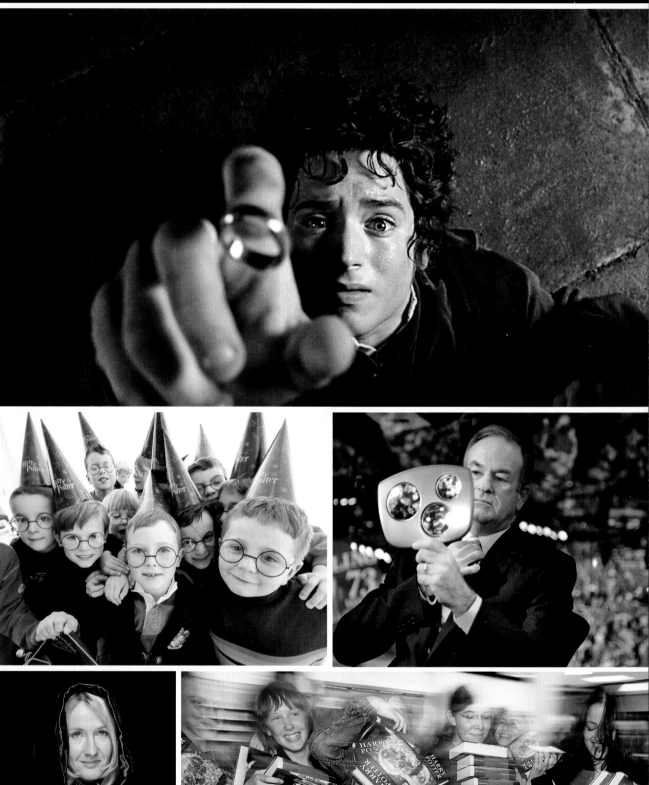

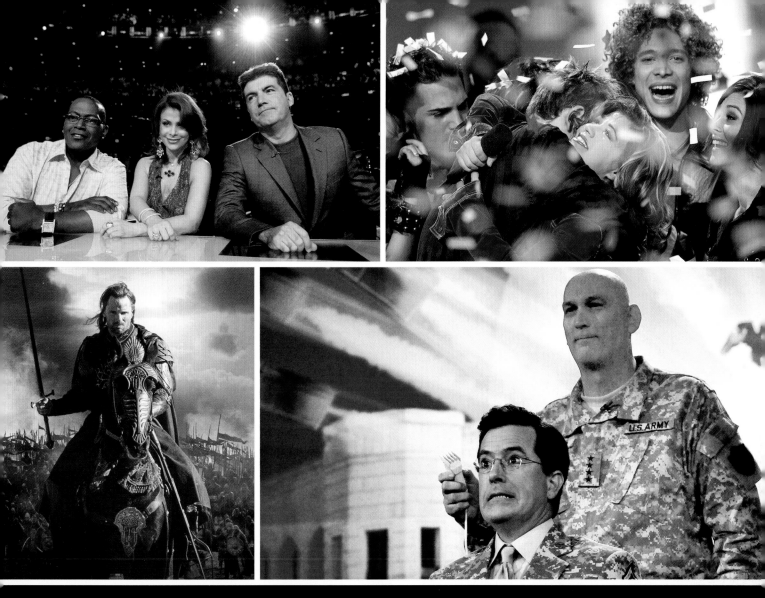

The ultimate arbiters of who would be the next big thing were Randy Jackson, Paula Abdul and Simon Cowell (top left), judges on the television phenomenon American Idol, whose first big winner was Kelly Clarkson, being congratulated by the runners-up on September 4, 2002. At the box office, nothing was more mammoth than the Lord of the Rings trilogy (opposite, top, and above left), which nearly equaled its commercial clout with its artistic achievement. Bill O'Reilly, checking things out in the mirror, was a force to be reckoned with as a conservative Fox News personality, a fact that gave rise to Stephen Colbert's satiric alter ego on Comedy Central (above, in Iraq, getting a standard-issue haircut from Ray Odierno, commanding general of the multinational force, in June 2009, and in 2007, below, discussing his run for the presidency with Meet the Press host Tim Russert). The Iron Chef series was hot and among its hottest chefs was Bobby Flay (below left). Casting her spell from the lower corner, opposite, is J.K. Rowling, literary sorceress of the Harry Potter novels, which set off frenzied buying worldwide (as exhibited in a Frankfurt, Germany, bookstore on July 21, 2007) and inspired a gazillion theme parties (like Richard Johnson's seventh-birthday bash in Boston on June 7, 2003; Richard is at the center of a horde of happy Harrys).

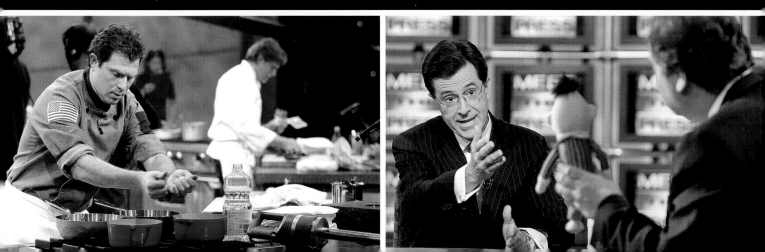

OF THE MOMENT

WHAT WITH 9/11 and the war in Iraq—and their myriad residual impacts—it had already been a thoroughly turbulent and transformative decade. And it was not yet half over.

Perhaps in 2004 we could take a breath?

That would be—it can be argued—the case. There were enormous events to come in '04, events that might have defined a less extraordinary decade (and one late-year event in particular that was immense by any reckoning). But, yes, in the United States at least, we could breathe.

Saddam Hussein was in custody, but securing Iraq continued to prove problematic, and it became ever more evident that the declaration of "mission accomplished" had been premature. Distractions from the war included, in January, the christening of the RMS *Queen Mary 2,* the largest passenger ship in the world; in February, the issuance in San Francisco of marriage licenses to same-sex couples, done as an act of civil disobedience; in March, John Kerry's triumph in nine of 10 Super Tuesday primaries, which assured he would be the Democratic nominee for President in November; in April, the signing of a cease-fire agreement between the Sudanese government and rebel factions, seeking to end violence in Darfur; in May, the addition of 10 members, including Poland, Hungary and the Czech Republic, to the European Union.

On June 5, 2004, Ronald Reagan, the 40th President of the United States, died at age 93 at his home in Bel Air, California, after having receded from the public view in recent years due to a battle with Alzheimer's disease. His death and the seven-day state funeral that followed (at right, Washingtonians bid farewell as the late President's motorcade passes) prompted not only tributes but also reflection and introspection. The nation, finding itself in perilous times, asked: What would Reagan have done? What would Roosevelt have done? What would the titans have done?

In the summertime of '04, the Statue of Liberty reopened after undergoing a security renovation in the wake of 9/11. A splendid Summer Olympics unfolded in Athens, Greece, where the ancient games had been born. In the fall, President Bush prevailed again by a slim margin in the general election, the controversial result coming this time in the state of Ohio, not Florida. Rancor remained strong throughout the land, but America was breathing again. We sat at our holiday tables and gave thanks. A year of relative normalcy had come and gone.

And then, on December 26, word started filtering from the East that something had happened in the Indian Ocean. We now know the facts: A huge earthquake, magnitude 9.3 on the Richter scale, had struck off the west coast of Sumatra, in Indonesia, spurring tremendous tsunamis throughout the region. Towns and cities in Thailand, India, Sri Lanka, the Maldives, Malaysia, Myanmar, Bangladesh and Indonesia were overwhelmed by the sea. Nearly a quarter of a million people were killed in one of the worst natural disasters in recorded history. Relief agencies scrambled to get to Southeast Asia as the year ended.

2004

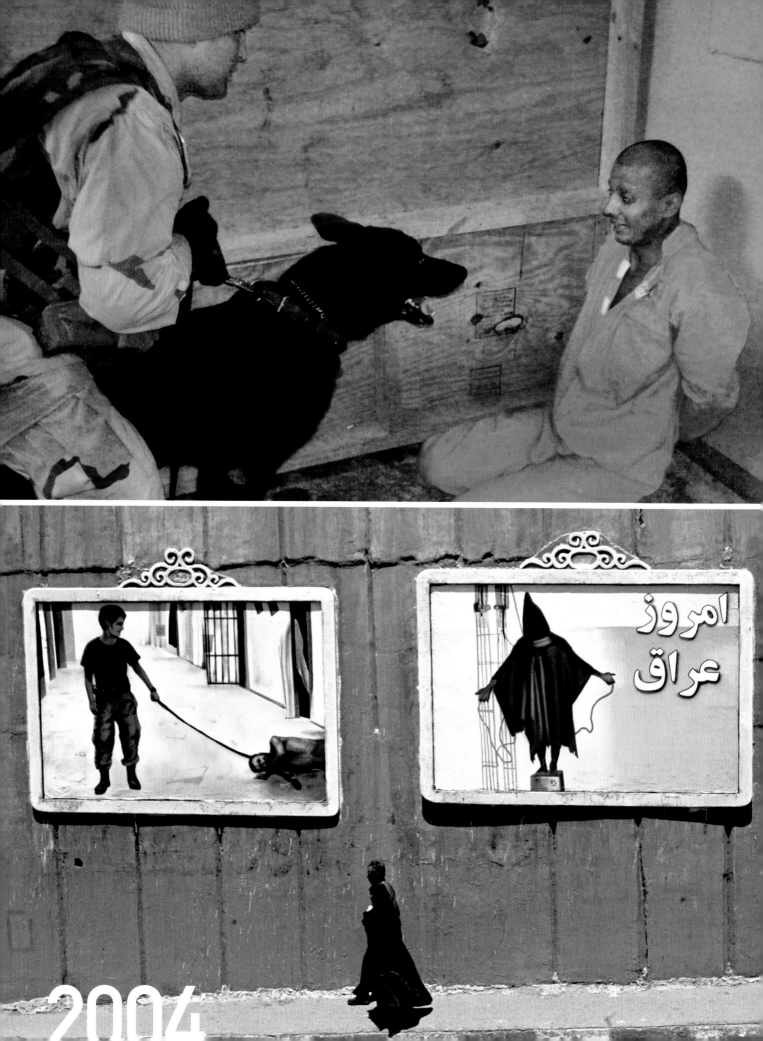

امروز عراق

2004

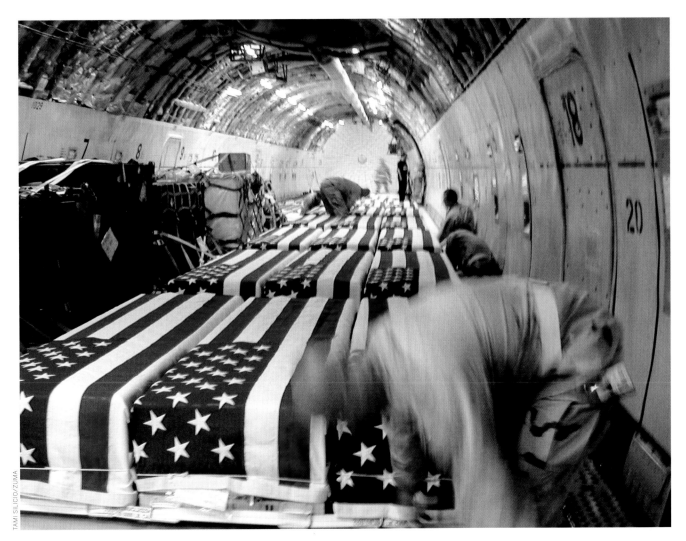

How Americans might have behaved in previous wars when the camera was not so ubiquitous has been recorded by historians and remembered by veterans, but nothing casts a glare in present time quite like a picture. The photographs that leaked out of Abu Ghraib prison in Baghdad, where U.S. forces were detaining and interrogating Iraqi combatants, shocked Congress and, subsequently, the American public. The picture at the top of the opposite page, showing an inmate being threatened by a dog, is one of the mildest; many other images portrayed the sexual degradation of prisoners as well as procedures that, in the opinion of many, constituted torture. The images did damage not only in the U.S. but around the world, where they were reproduced to inflame anti-American sentiment (opposite, bottom, in Iran). Above: A picture again speaks a thousand words. The Pentagon had, since 1991, banned the dissemination of photographs of coffins containing the remains of U.S. soldiers, and when this image was published, the Kuwait-based cargo worker who took it lost her job. But for the wider world, the photo served the same purpose as the famous pictures that appeared in LIFE during World War II, the Korean conflict and the Vietnam War: It showed the reality of what was happening.

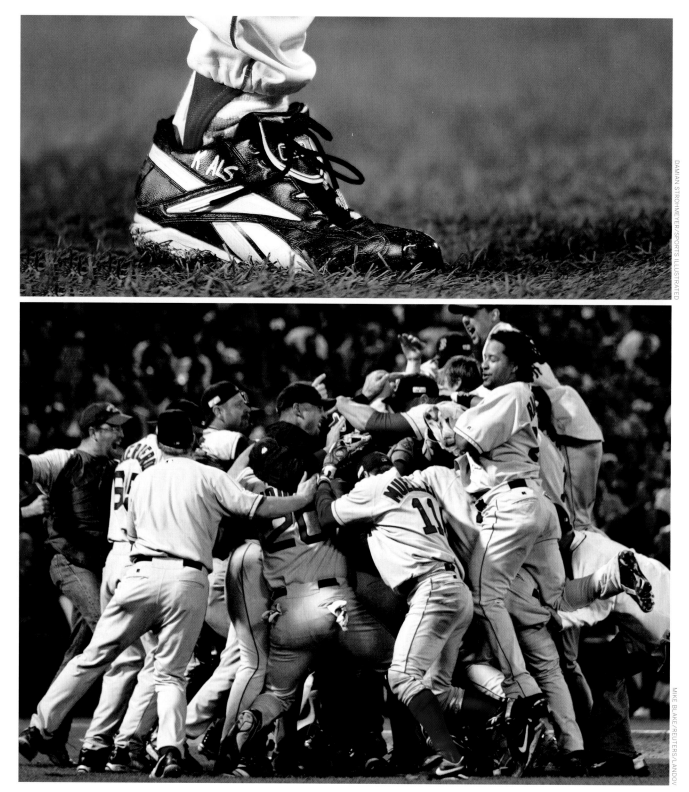

They famously hadn't won it all since 1918, but in October of 2004, the Boston Red Sox bested their archrivals, the New York Yankees, and then the St. Louis Cardinals to become world champions. Among the heroes was Curt Schilling, who pitched despite a torn tendon sheath that bled openly and made his hosiery visually riveting (top). In another period, the Sox would have been baseball's biggest story, but this decade was defined by the steroid scandal. Opposite: In 2004, even as he marched toward 700 home runs, Barry Bonds (top left) was under a cloud, and when Roger Clemens (top right) told Congress the next year that he had never used performance-enhancing drugs, he set himself up for a perjury inquiry. Center: Yankee teammates at a confessional 2009 appearance by star Alex Rodriguez look more like a tribunal than a support group. At bottom left is Rodriguez that day, and at right is Manny Ramirez of the L.A. Dodgers, returning after a 50-game suspension for steroid use, also in '09. Ramirez was a member of the fairy-dusted 2004 Sox.

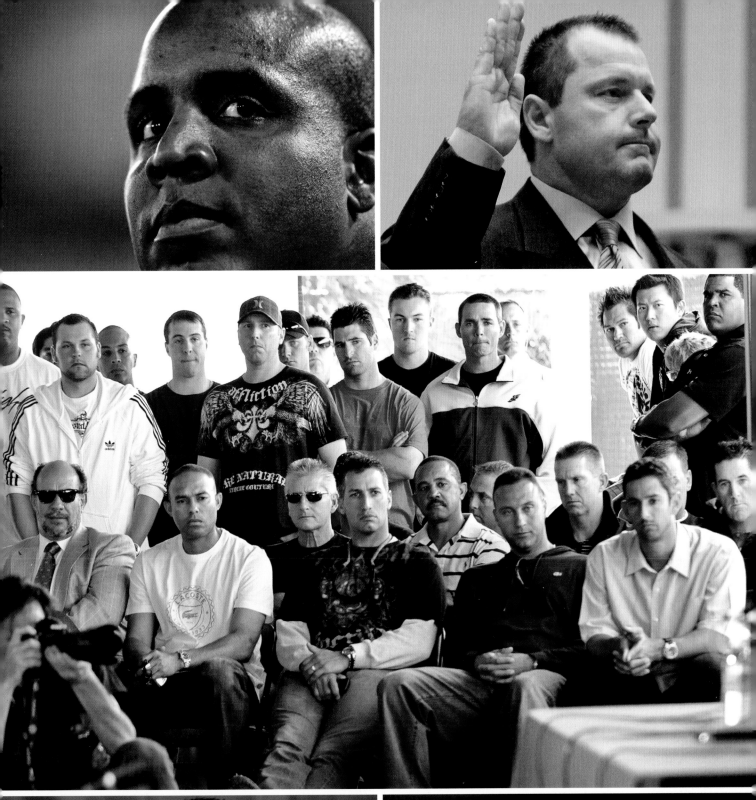
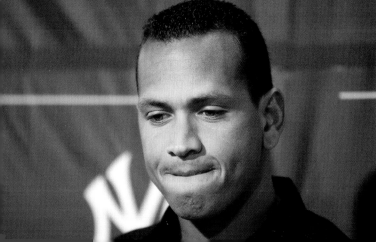
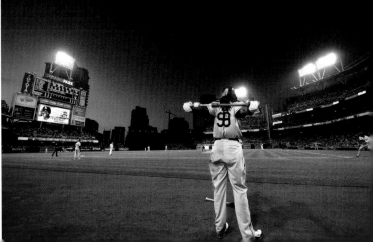

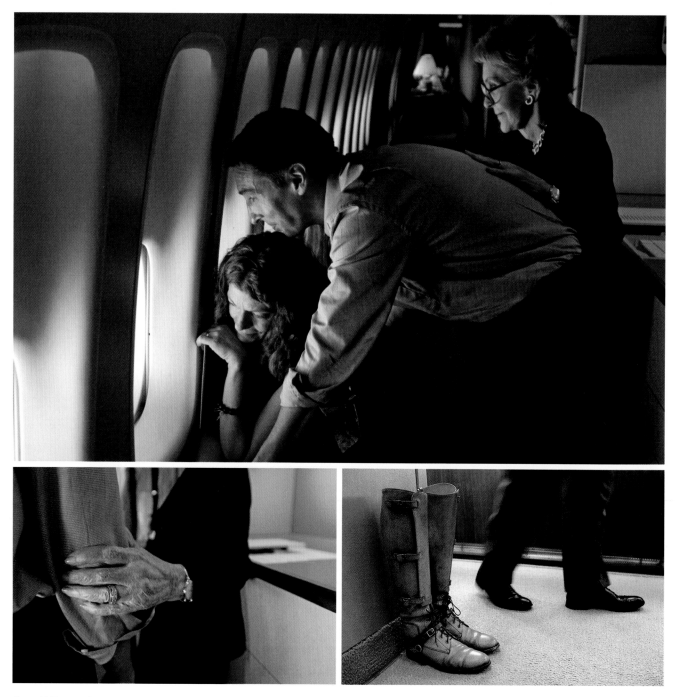

Ronald Reagan's life represented an extraordinary American saga, and his funeral was a world-gathering event, with old allies like Margaret Thatcher of Great Britain and even Michael Gorbachev of the former Soviet Union arriving to pay respects. There was much pomp and circumstance to the proceedings, as befits a legendary leader. The weeklong state funeral began in California, where there was a viewing of the casket at the Ronald Reagan Presidential Library in Simi Valley (108,000 people paid their respects). The casket then proceeded to Washington, D.C., where the late President lay in state in the Capitol Rotunda (more than 100,000 more bade farewell). A funeral service at the Washington National Cathedral on June 11—a day that President Bush declared a time for national mourning—was attended by 4,000, including four former U.S. Presidents and dignitaries from 165 nations. From there it was back to California for the interment ceremony at the library. The world's press covered all the grandeur of the events, but photographer Pete Souza was an intimate of the Reagans and was able to document the story from the inside. In this series of pictures, the family is headed back west aboard the VC 25-A presidential aircraft. Top: Ron Jr., his wife, Doria, and his mother, Nancy, peer out the window as the plane passes over Tampico, Illinois, where Ronald Reagan was born on February 6, 1911. At bottom left, Nancy supports Ron during the flight, and at bottom right are the late President's riding boots. Opposite: Ron says goodbye to his father (top), and later at the burial (bottom), he, his mother, his sister, Patti, and his half brother, Michael, grieve. These were the moments that mattered, in a memorial that played out more broadly and grandiosely for the world audience.

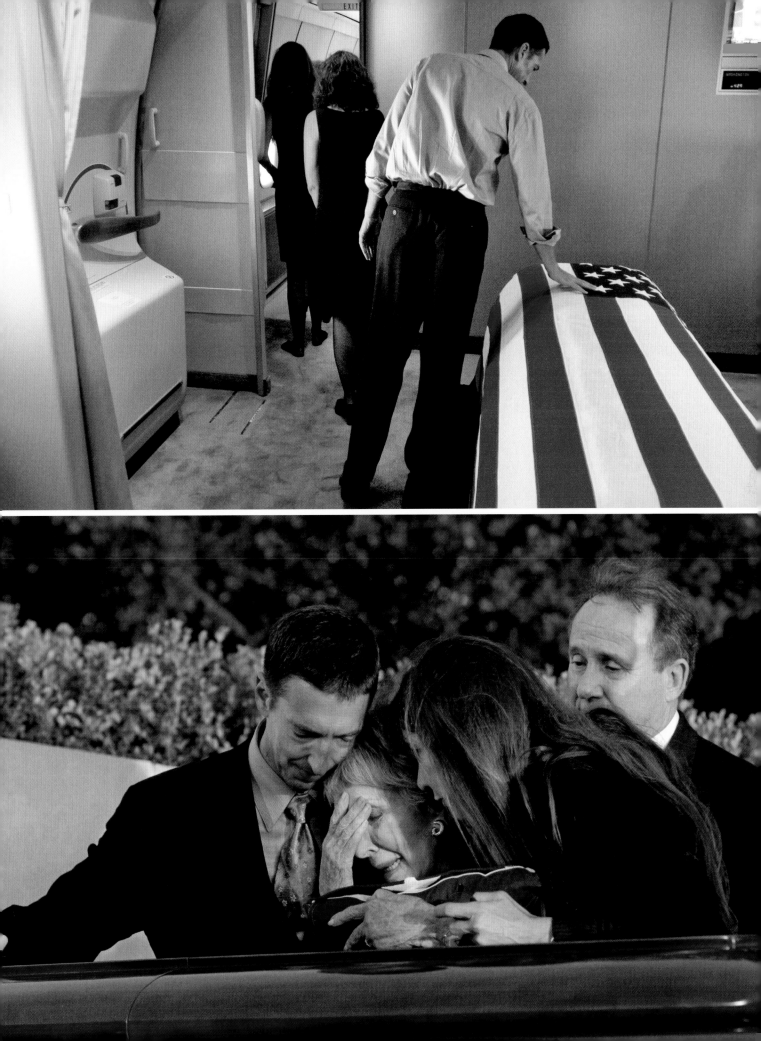

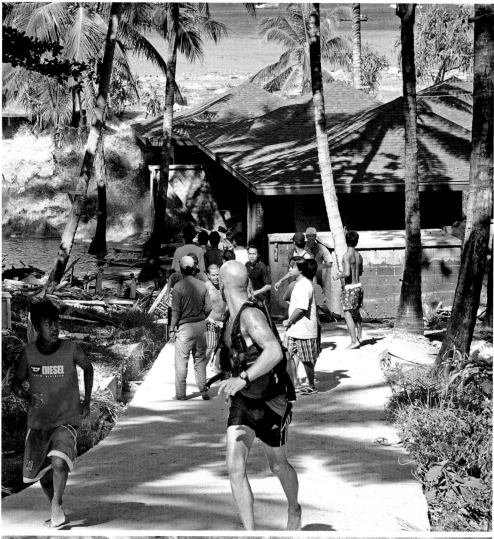

The low-lying coastal areas of Southeast Asia are particularly vulnerable to tumult from the sea, and when "the tsunami" hit, all of their vulnerabilities were exposed. It was initially an earthquake that struck, with the tsunamis being the ocean's violent reaction. It is difficult to overestimate the enormity of the Great Sumatra-Andaman Earthquake, an undersea megathrust 19 miles beneath the surface of the Pacific Ocean that was the second most powerful quake ever recorded on a seismograph and the longest lasting—nearly 10 minutes—ever observed. This was an earthquake so big it caused the entire planet to shake. The waves traveled fast from the epicenter. A tsunami can move at up to 670 miles per hour in 30,000-foot-deep water; it can overwhelm nearby coastal areas in minutes and can cross the Pacific in less than a day. By the time the Asian Tsunami of 2004 was over, it would claim lives as far away as South Africa and Kenya. It would kill between 130,000 and 170,000 people throughout Indonesia, more than 35,000 in Sri Lanka, perhaps as many as 18,000 in India and 8,000 in Thailand—one of the worst natural disasters in human history. At top left: A wave crashes ashore at Koh Raya, part of Thailand's territory in the Andaman Islands. Bottom: Supat Gatemanee, 19, was working at a beachfront café on the resort island of Phuket, Thailand, when he was swept away; he survived the ordeal. Opposite: The eight-year-old son of this grieving father in Cuddalore, India, did not.

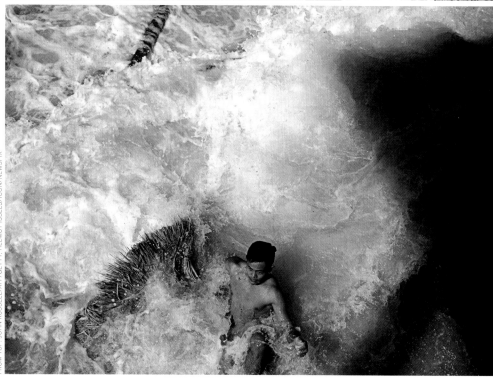

2004

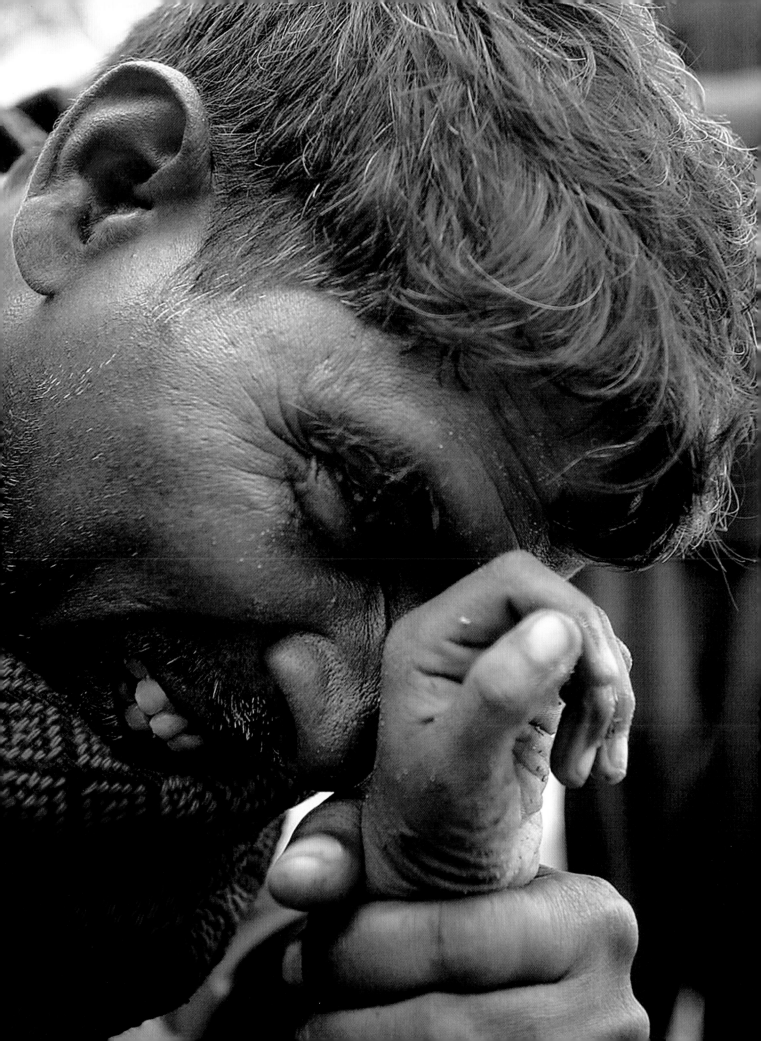

THE FORMER YEAR ended with "the tsunami," and in America 2005 would be marked by another natural disaster that would become known simply as "Katrina." As with the many aftershocks of 9/11 and the drawn-out involvement in Iraq and Afghanistan, the piteous ramifications of Katrina trailed on through the remainder of the decade—and beyond.

Earlier in the year than Katrina, oddities as well as significant events grabbed the headlines. In January, Adriana Iliescu, a retired university professor in Bucharest, gave birth to a girl at age 66, setting a dubious-achievement record that would be broken the very next year. In February, North Korea said it had nuclear weapons. In March, Terri Schiavo died after being disconnected from life support in Florida, ending a case that had divided the country. In April, Pope John Paul II, one of the most influential figures of the 20th century, died after nearly 27 years on Saint Peter's throne, the second-longest pontificate ever. In May, a story in *Vanity Fair* finally outed former FBI official Mark Felt as Watergate's Deep Throat. In June, quietly at first, the most active Atlantic hurricane season in recorded history began with Tropical Storm Arlene, which eventually spent itself on the Florida Panhandle. (When all was said and done in this terrible period—which wouldn't end until early 2006, the latest terminus ever for an Atlantic season—there would be 2,280 deaths and damage of an estimated $128 billion, as Dennis and Emily and Rita and Wilma and, of course, Katrina wreaked unimaginable havoc.) In July, Appeals Court Judge John G. Roberts Jr. was nominated to the U.S. Supreme Court as a replacement for the retiring Sandra Day O'Connor, the first woman ever to serve on the high bench.

The year was yet relatively quiet, especially when measured against what had already transpired during the decade. But on August 23, a storm began to coalesce over the Bahamas. It would live and grow for precisely a week before dissipating, and it would travel. It worked its way into the Gulf of Mexico, became a monstrous Category 5 hurricane and stared ominously at the U.S. coastline. Then, on August 29, it made landfall and churned northward through the entire state of Mississippi. Initial hopes that the glittering city of New Orleans in neighboring Louisiana had dodged the bullet proved tragically ill founded when coastal flooding crested above 30 feet and the levees began to surrender. The city went under. Emergency response was frenzied, heroic, inadequate and late by turns, and the result was abject tragedy. Katrina killed more than 1,800 people and left thousands upon thousands homeless—displaced, cast to the wind, refugees to alien cities and states throughout the country.

In September, Roberts was nominated and then confirmed as Chief Justice; in October, Saddam Hussein went on trial; in November, surgeons in France performed the first human face transplant; in December, New York City's subway and bus workers went on strike for three days . . .

But in New Orleans, none of this was news. Katrina lingered, and all was death and despair.

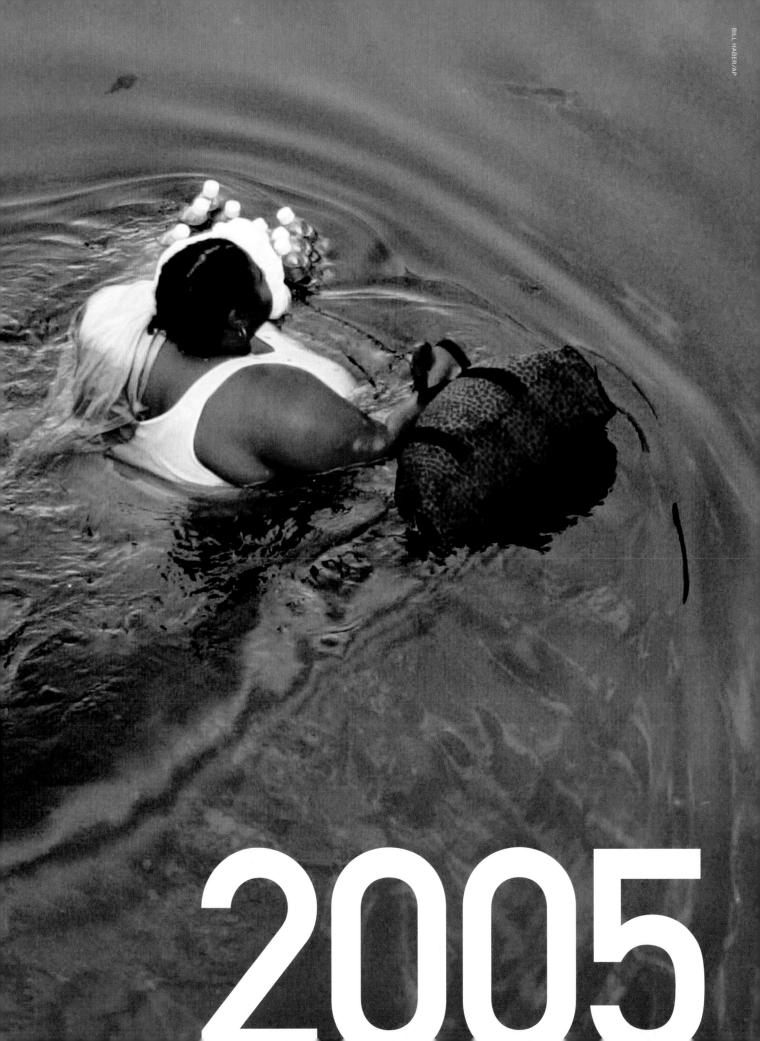

2005

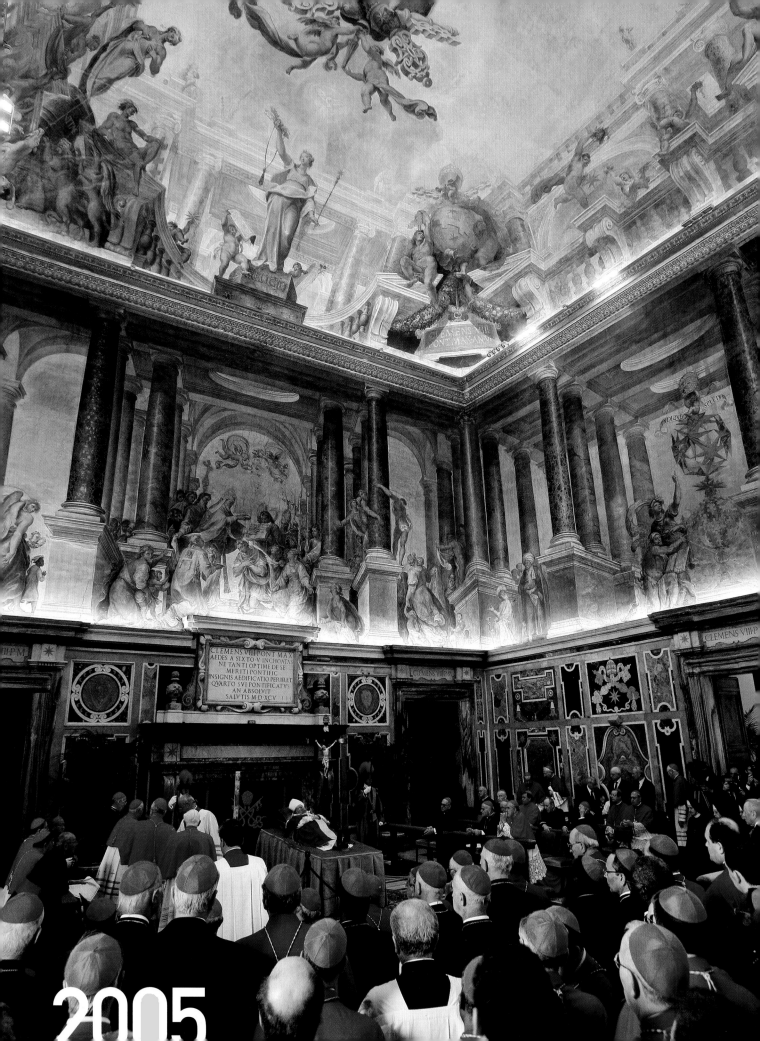

2005

The Reverend Billy Graham once wrote an appreciation of Pope John Paul II for LIFE in which he averred: "Few individuals have had a greater impact—not just religiously but socially and morally—on the modern world." Just so. The great events of the 20th century influenced Karol Wojtyla's life, and as pope he influenced events in turn. Born in southern Poland, he saw Nazi tanks roll through his homeland; the infamous death camp at Auschwitz was established only an hour's journey from his town. He entered a clandestine seminary and subsequently developed a reputation as a bright, charismatic cleric. He rose through the church hierarchy and in 1978 became the first non-Italian pope in more than four centuries. He proved to be an indomitable force. Working behind the scenes with other world leaders, he played a crucial role in the fall of Communism. Traveling more miles than all previous popes combined, he brought the worldwide population of Roman Catholics up to a billion strong. Four million pilgrims made their way to Rome to honor him when he died (opposite and below, lying in state in the Clementine Hall at the Vatican). Below right: Papal outfits in three sizes await his successor—whomever he might be—as the College of Cardinals convenes. The man chosen is Joseph Ratzinger of Germany, who becomes Pope Benedict XVI and, later in the year, prays at the tomb of John Paul II in the crypts below Saint Peter's Basilica (bottom).

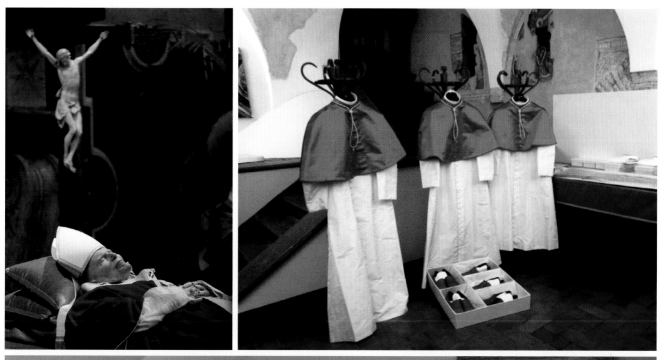

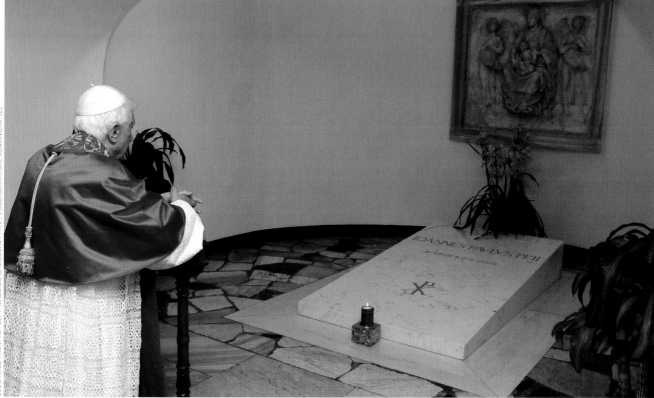

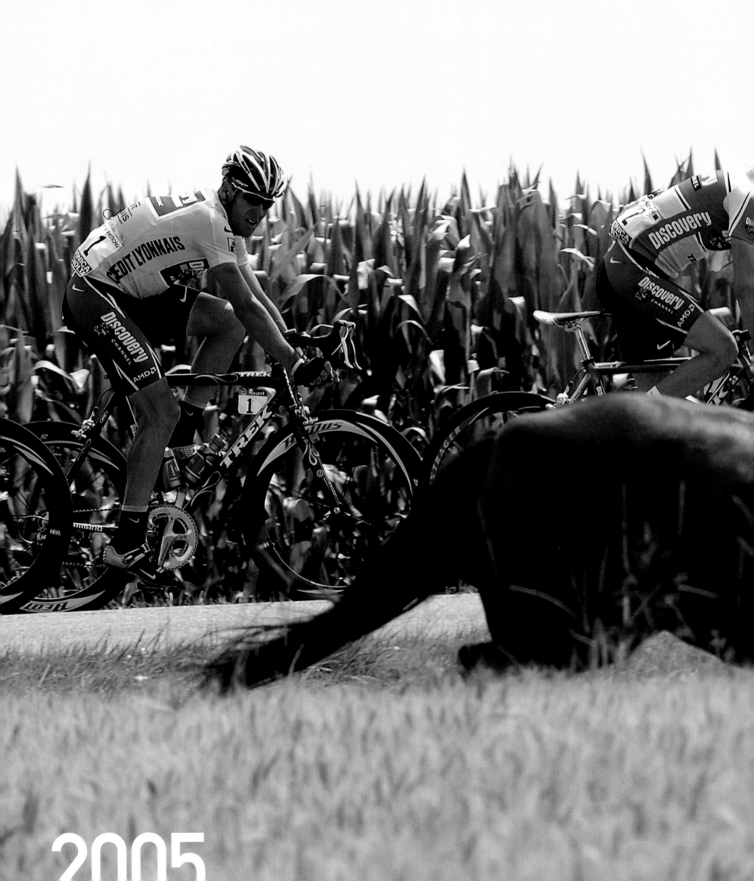

2005

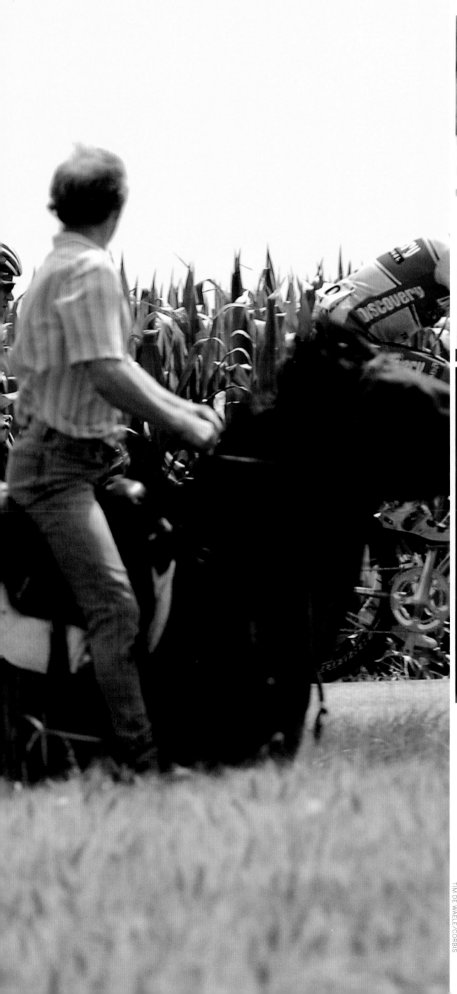

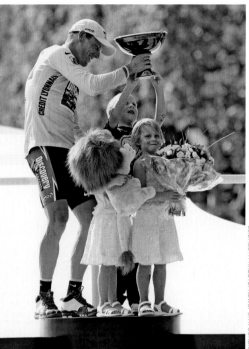

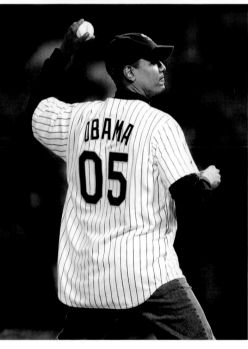

We could have selected any year in the first half of the decade to celebrate the American cyclist and cancer survivor Lance Armstrong, but we choose 2005 since it is in this year that he wins his record seventh Tour de France (in both pictures, he's in the yellow jersey; on this page he celebrates with son Luke and twin daughters Isabelle and Grace). In other sports news, a neophyte senator from Illinois gets to throw out the first pitch at a playoff game hosted by his beloved Chicago White Sox, who will go on to win their first World Series since 1917. The senator, too, has a bright future ahead of him.

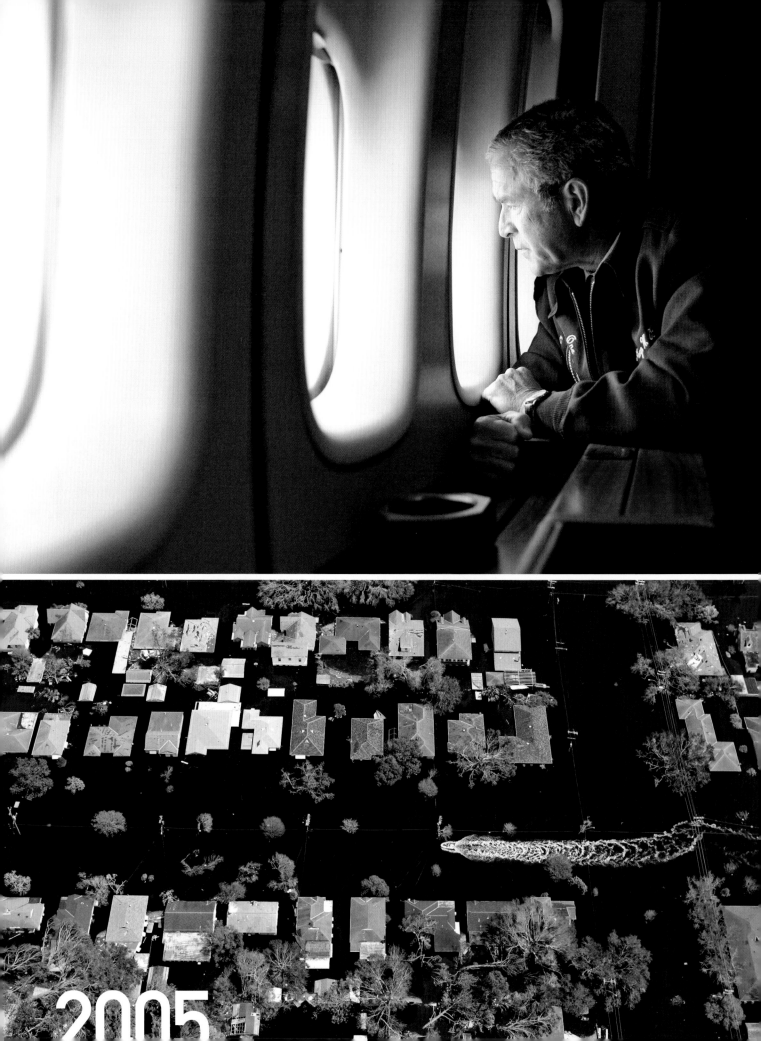

2005

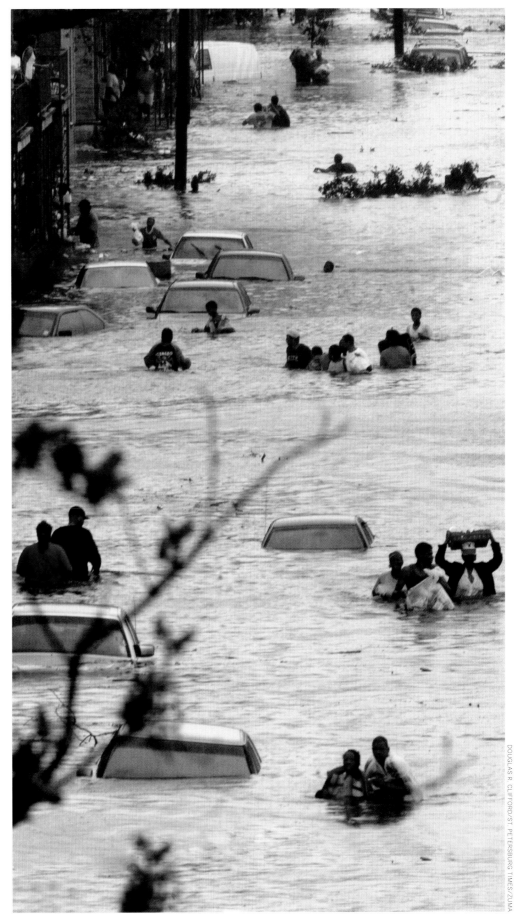

A recent estimate claims that 1,836 people lost their lives because of Hurricane Katrina, so it wasn't the deadliest in American history: The Okeechobee Hurricane of 1928 took the lives of 2,500 Floridians, and the Galveston Hurricane of 1900 killed as many as 12,000 Texans. Katrina was only the sixth-strongest Atlantic hurricane and the third-strongest one to make landfall in the U.S. Yet it is widely considered our most devastating storm. The destruction and misery wrought by this tempest ravaged a cherished and historic American city before our eyes. As mentioned a few pages ago, Katrina was born in the Bahamas on August 23 in what was shaping up to be the vicious hurricane season of 2005. It became the second Category 5 hurricane of the year and, while at sea, intensi-fied into one of the most powerful storms ever mea-sured. On August 29, Katrina, which had been downgraded to a Category 3 storm, made landfall in Louisiana and Mississippi. The full brunt of the hurricane hit just east of New Orleans. Then the levees began to fail. Nearly all in the metropolitan area were breached, and 80 percent of New Orleans and its nearby parishes and precincts went under. Right: On August 29, the swelling Mississippi River floods North Claiborne Avenue in the Orleans Parish. Opposite, top: President Bush surveys the situation from the air two days later in a photograph that was seized upon by critics as symbolic of Washington's inertia during the crisis. Opposite, bottom: Two weeks after the storm hit, the city is still inundated.

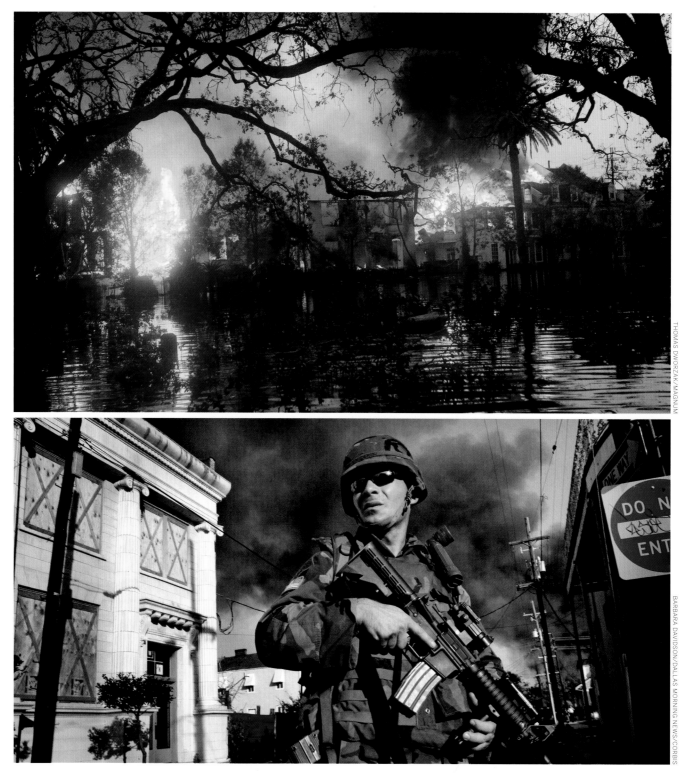

THOMAS DWORZAK/MAGNUM

BARBARA DAVIDSON/DALLAS MORNING NEWS/CORBIS

FROM TOP: BEN SKLAR/AP; ERIC GAY/AP

The pictures on these pages tell the story of what we remember today as a slow-moving, excruciating, heartbreaking horror show—one of death, crime, terror, government ineptitude, constant, abject pain and occasional heroism. Having caused more than $80 billion in damage, Katrina was the costliest natural disaster in U.S. history. But the storm's final price cannot be measured in dollars; she struck a blow to America's heart and soul. Top: A fire rages in the Garden District; according to police and firemen, it had been set by looters who were seen fleeing the area by boat. Above: A National Guardsman blocks a road leading to a 19th century apartment building that has also been set ablaze near the city's renowned Magazine Street antiques district. Opposite, top: On Route 90 in nearby Bay St. Louis, Mississippi, a volunteer emergency crew rescues the Taylor family from the roof of their Chevy Suburban. Opposite, bottom: Evelyn Turner weeps beside the body of her common-law husband, Xavier Bowie, who had lung cancer and died in their New Orleans home when his oxygen supply ran out.

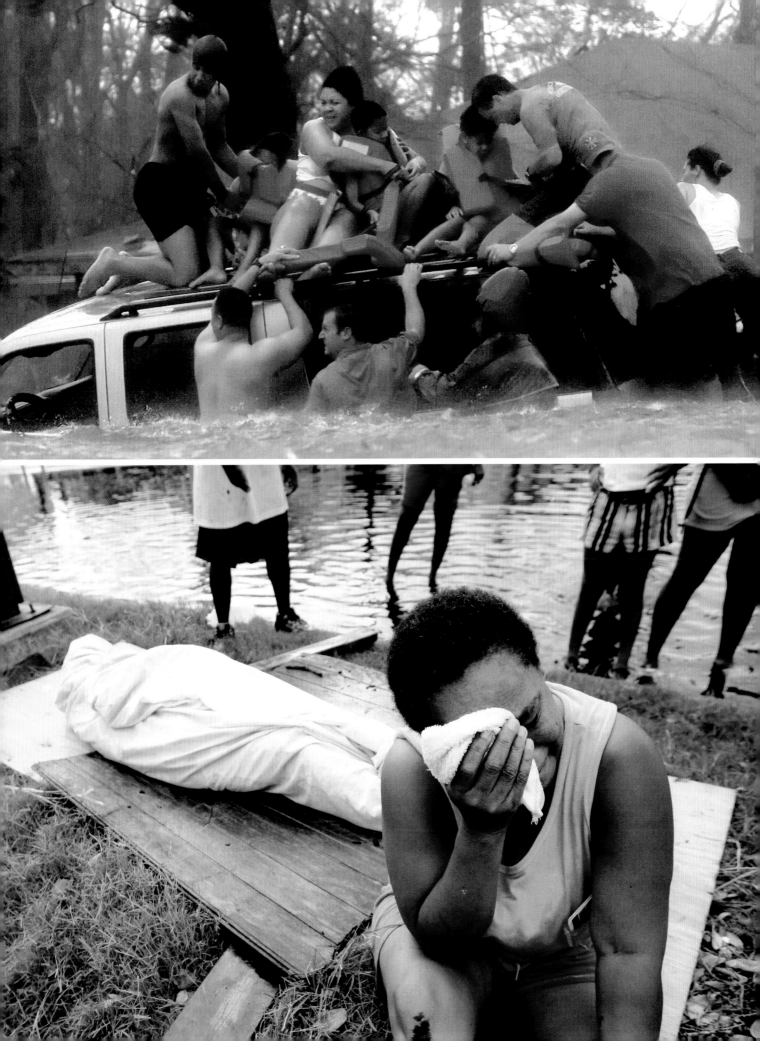

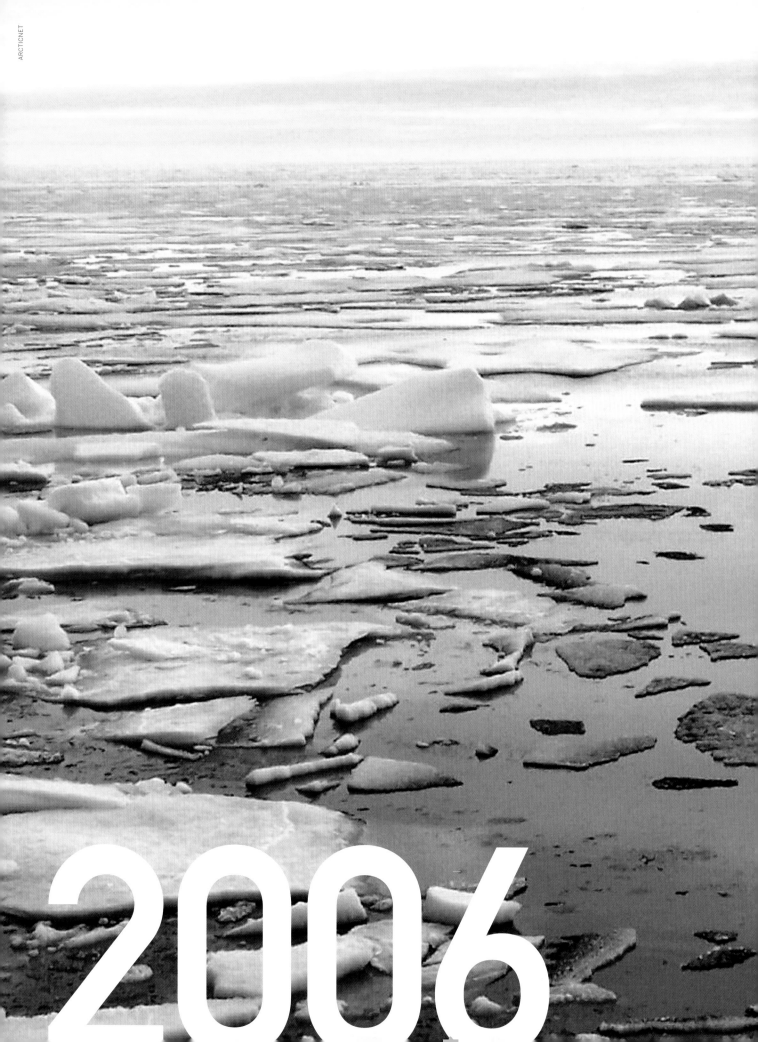

2006

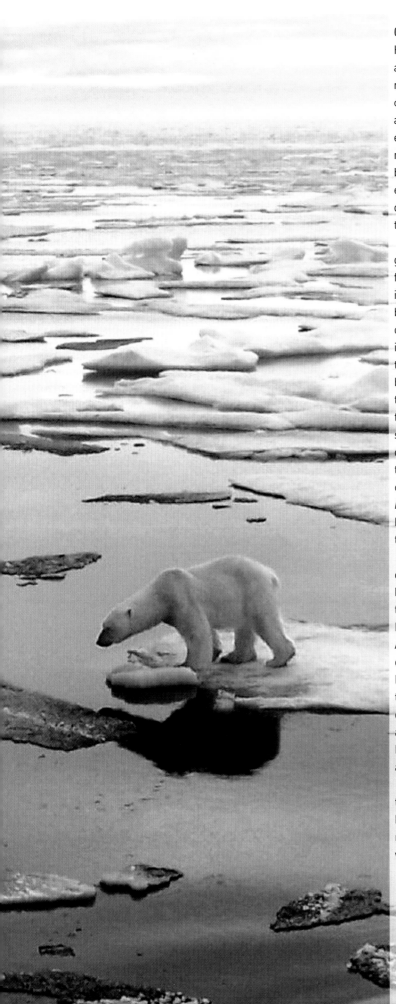

ON JANUARY 1, only the 12th day of summer in the Southern Hemisphere, the thermometer in Sydney, Australia, topped out at 113 degrees Fahrenheit, making it the hottest day in the city's recorded history. The next day, the roof of an ice rink in Germany collapsed after an extraordinarily heavy snowfall in the Alps, and 15 people were killed. Four days after that, the longest-ever Atlantic hurricane season drew to a close—finally, after more than six months of activity—when Tropical Storm Zeta blew itself out. Scientists and other serious-minded people everywhere were saying—while taking care never to draw a direct line between the general theory and a specific event—that something was wrong with the planet.

This had been on the table for some time, of course: that global warming might be affecting climate patterns and that further and more dire consequences lay ahead if we did nothing to alter our industrial ways. But in 2006, the issue was brought to the fore when Al Gore gave it a human face (as opposed to that of a beleaguered polar bear watching his Arctic ice habitat dwindle). After having conceded the 2000 presidential election to George W. Bush, Gore had paused, then redoubled his efforts in his signature cause: the environment. He put together a compelling slide show and took his lecture tour on the road. Others thought there might be a film in Gore's presentation, and that became *An Inconvenient Truth,* which debuted early in '06 at the Sundance Film Festival and went on to win the Academy Award for Best Documentary Feature. A companion book by Gore, *An Inconvenient Truth: The Planetary Emergency of Global Warming and What We Can Do About It*, became a No. 1 best-seller. President Bush said he didn't plan to see the film, and we can assume he didn't read the book.

Global warming would remain a hot topic as the first decade of the 21st century drew to its close, and other things that were highlighted in 2006 continued to be relevant as we looked to the future: NASA's Mars Reconnaissance Orbiter entered the Red Planet's orbit in '06, and the Blu-ray Disc was introduced. Avian flu surfaced and spread, heralding the later appearance of swine flu in 2009, and North Korea test-fired missiles. Cuba's President Fidel Castro relinquished power to his brother Raul, then underwent surgery; Raul would be firmly in charge by decade's end. Pope Benedict XVI seemed to challenge Islam in a lecture, and in response, churches were attacked in Palestine. In November, anticipating the holiday market, both PlayStation 3 and the Wii were released.

On New Year's Eve, the Met Office in Great Britain announced that England had experienced its warmest year since record keeping had started in 1659. Scientists and other serious-minded people everywhere were saying that something was wrong with the planet.

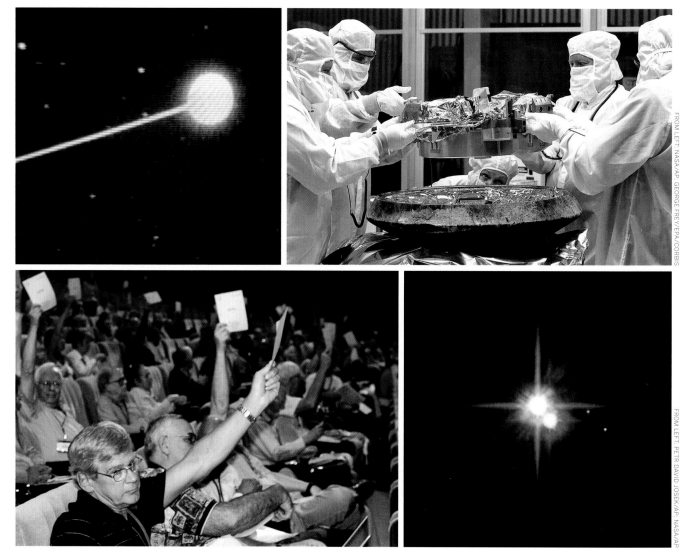

A decade earlier, NASA had begun construction of the Stardust spacecraft and launched it in 1999. In 2004, it flew close to the Wild 2 comet and extracted dust samples (top left) and photographed the spheroid's nucleus in order to gather information, it was hoped, about the origins of the solar system. Over time, Stardust also collected interstellar dust, and its samples skidded to Earth in a capsule traveling nearly 29,000 miles an hour in the Utah desert on January 15, 2006. Then humans went to work on the material (top right), and among the cool things they found was glycine. What did that mean? Dr. Carl Pilcher, director of the NASA Astrobiology Institute, explained: "The discovery of glycine in a comet supports the idea that the fundamental building blocks of life are prevalent in space and strengthens the argument that life in the universe may be common rather than rare." Wow. Above right: Another discovery was made a month later. In this photograph from NASA's Hubble Space Telescope, we can see that Pluto (the brightest light) is orbited not only by the moon Charon (the second brightest) but by two other, smaller moons (the two white dots). This nifty news did nothing to dissuade voters at the International Astronomical Union from voting (above left) to demote Pluto from a planet to a dwarf planet at the organization's general assembly in Prague in August. If Pluto had a rough year, Mars had a banner one, yielding wonderful images and info to NASA's rovers and orbiters. Opposite, clockwise from top: The Chasma Boreala, a long valley cutting into Mars's north polar ice cap; a cliff in Victoria Crater; and an overhead view of the crater, which is about half a mile in diameter.

2006

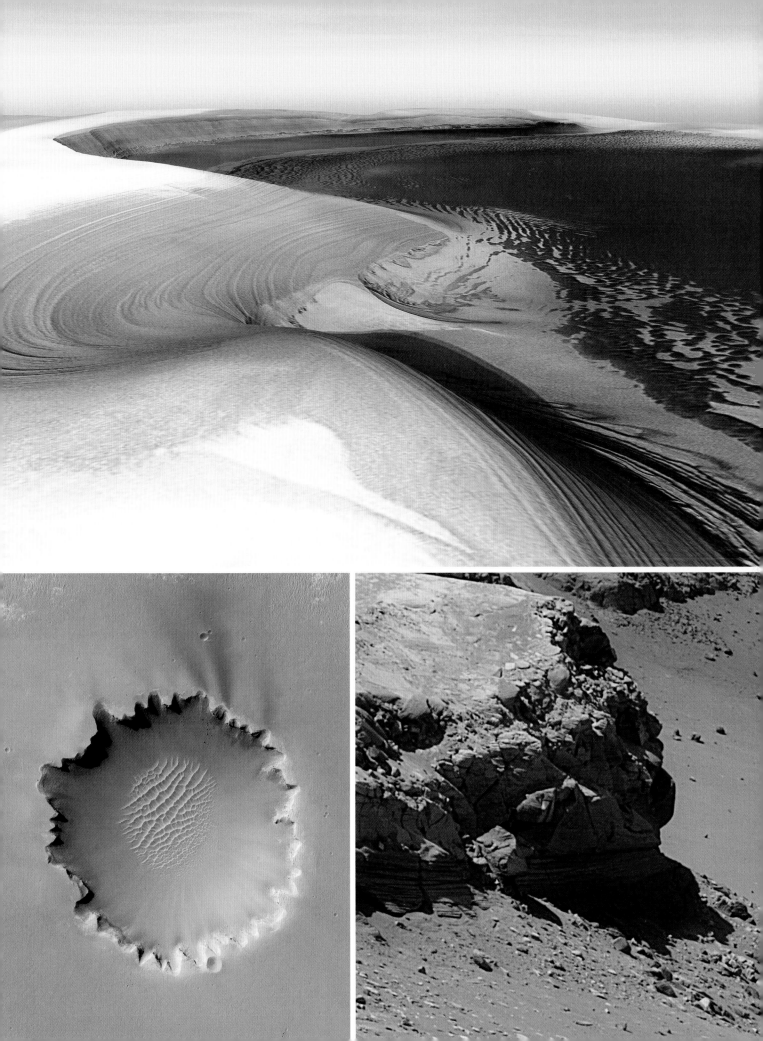

The incendiary message of *Al Gore*'s Inconvenient Truth road show (top) was that, succinctly put, the planet was going to hell in a handbasket. There did seem to be some circumstantial evidence. Center: One of the worst droughts ever recorded in the Amazon region has left Brazil's Curuai Lake nearly bone-dry. Bottom: The Harding Icefield in Alaska's Kenai Fjords National Park looks lovely in its autumn colors, but beneath the beauty lies the fact that the ice, like that elsewhere in the Arctic and sub-Arctic, is diminishing, and the fauna and flora are struggling to adapt to a changing landscape. Opposite, top: In the Antarctic, too, there is change, and the massive Wilkins Ice Shelf has started to disintegrate. Bottom: As if on a life raft, walruses float on pack ice during the spring breakup in the Chukchi Sea off the northern coast of Alaska.

2006

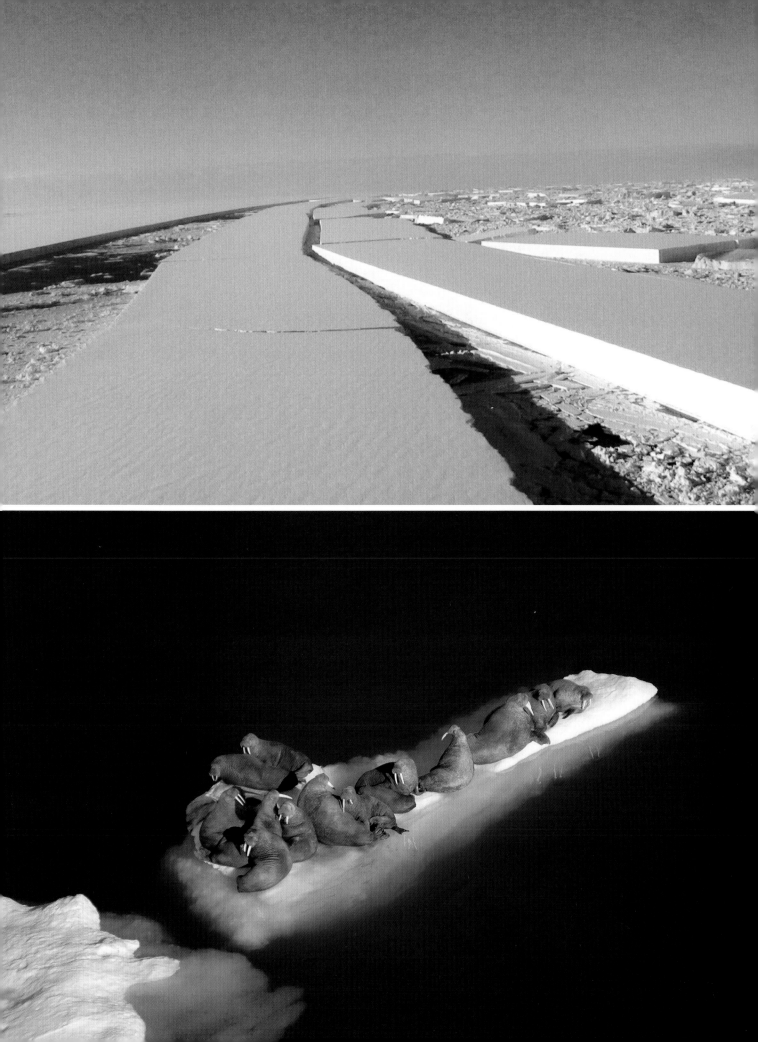

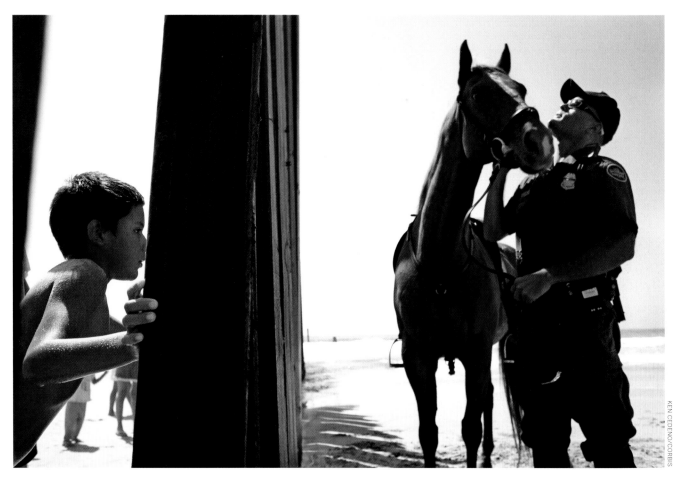

Above: On August 24, a young Mexican boy peeks through a tall fence along the beach at Border Field State Park south of San Diego, as Customs and Border Protection agent Rodney Feige and his horse, Deuce, casually patrol. Legal and illegal immigration was a hot topic throughout the decade, but never hotter than it was in '06. Opposite: On March 25, a crowd of 500,000 takes to the streets of Los Angeles (bottom) to protest proposed federal legislation that, in their view, seeks to crack down on immigrants. Two weeks later, throughout the land, a national day of action is called to send the same message, and tens of thousands pour forth in several major cities. In Indianapolis, as many as 20,000 participate, including marchers who stand behind an American flag at the Marion County building downtown (top). By decade's end, immigration reform is still a simmering issue, even if it has been back-burnered by the flailing economy.

2006

OF THE MOMENT

IT WAS A DECADE of astonishing invention and innovation, as tantalizing new toys and great gadgetry conspired to completely change the way we lived. In addition to all these cool new things, there were the latest trends—some of which came and went, some of which stuck. Remember?

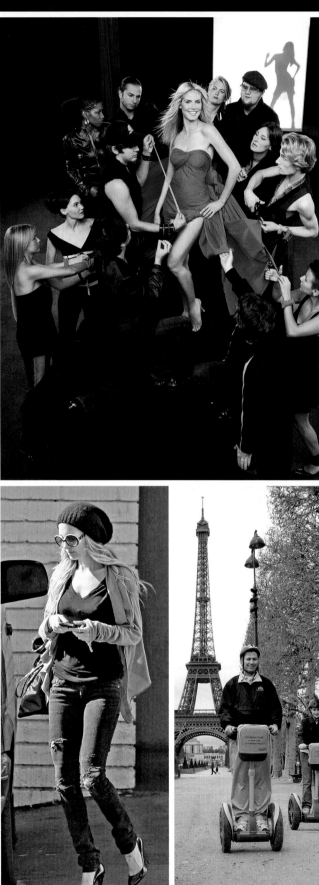

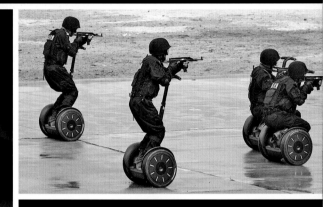

Every decade will have its fashion trends—skirts will rise or fall, lapels will widen or narrow, haircuts will be acceptable or execrable—but it's hard to say for certain how the past 10 years will be judged. They weren't the 1970s, probably, but they weren't Astaire and Rogers, either. Trying to set or uphold standards—or just get big ratings—was the TV hit Project Runway, costarring supermodel Heidi Klum (left). Meanwhile, going with the latest look—even if it involved ripped skintight jeans with heels, way-large sunglasses and that hat—was, of course, professional celebrity Nicole Richie (bottom left). Many other women decorated themselves with tattoos, including Amy Winehouse and Angelina Jolie on the opposite page, the latter seen with her squeeze, Brad Pitt. Another big trend during the decade was the upward one in petroleum prices, leading to gaspump costs like the ones in San Diego in 2008 (opposite, top left) and ripostes like the one at Mountain Crossing Mercantile in Jonas Ridge, North Carolina (top right). What was the alternative to gas-guzzling cars? There were certainly plenty of ideas. On this page, Segway Personal Transporters are utilized by American tourists in Paris in 2004 and by paramilitary police in China preparing for the 2008 Beijing Olympics. On the opposite page are an electric car "gassing up" in London in 2009 and actor Leonardo DiCaprio tooling around L.A. in 2002 in a $7,495 eco-friendly Ford TH!NK Neighbor vehicle, also powered by electricity. Which of these might stick? Only tomorrow knows.

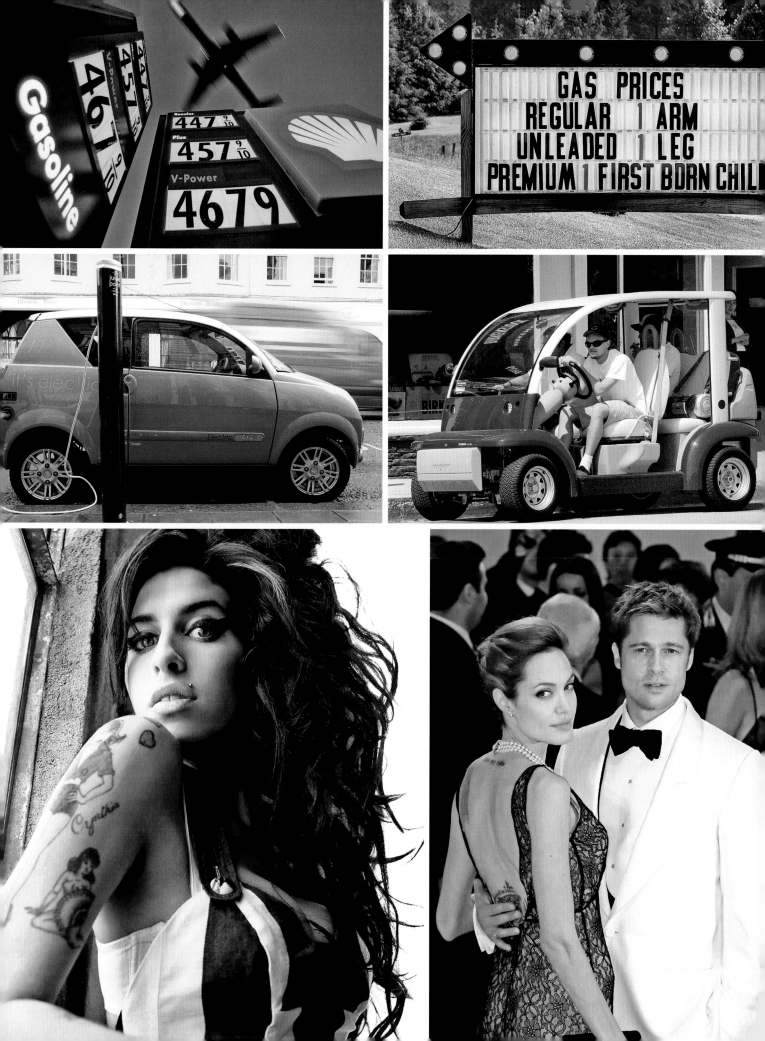

How we communicated, worked and played was transformed utterly in this decade. Twitter, a recent phenomenon, was employed in ways that were frivolous, meaningful and truly important—as when tweets shouted the truth from street demonstrations in Iran. Below center, we see a computer screen displaying actor Ashton Kutcher's Twitter page on April 17, 2009, shortly after he became the first person to attain one million followers. Kutcher, CNN and Oprah Winfrey pledged to mark the milestone by purchasing mosquito bed nets to combat malaria. Below at right, Martha Stewart tweets a broccoli pasta recipe only 138 characters long (two under Twitter's limit). President Obama, seen (bottom left) before a health insurance rally in College Park, Maryland, is an admitted BlackBerry addict, while vice president Biden (opposite, bottom right) digs his iPod, as do the young clubbers adjacent to him at an iPod-mp3 party in London's Progress Bar on February 27, 2005. Interactive video games were huge, and in September 2009, The Beatles: Rock Band (bottom right) was released, as were remasterings of their albums, spurring a new wave of Beatlemania. The Wii had kids in Berlin faux-boxing in front of their TVs (opposite, top left) and seniors bowling at an assisted-living facility in Hopkinsville, Kentucky (center). Social networking worked for kids, too, who could virtually play at Club Penguin (opposite, top right, is the club's cofounder Lane Merrifield). And then there was YouTube. In an event that aptly reflects just how enormous that enterprise was and is, in the photograph on the opposite page at center right is an April 15, 2009, performance by the YouTube Symphony Orchestra in New York City's Carnegie Hall, the auditions for which were conducted online.

myself. getting ready for Oprah.
14 minutes ago from TweetDeck

for anyone who missed it here's the vid on t
http://bit.ly/3UpiEF
about 7 hours ago from TweetDeck

YOU GUYS are AMAZING http://twitpic.com/
about 7 hours ago from TweetDeck

Victory is ours!!!!!!!!
about 8 hours ago from web

http://www.malarianomore.org/
about 8 hours ago from web

we are reporting live on http://www.ustream
about 8 hours ago from web

We are at the finish line we need one last pu

OF THE MOMENT

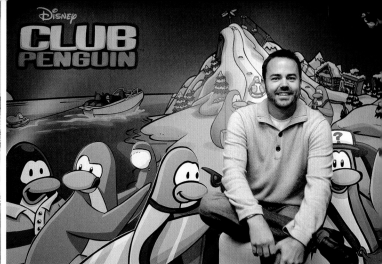
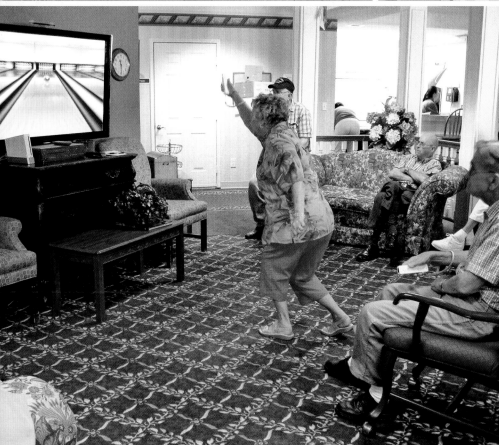

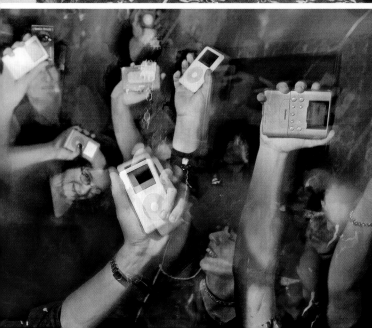
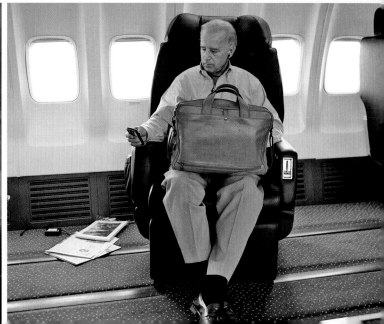

20,000 additional troops to the conflict in Iraq; the Solomon Islands were hit by a Richter scale magnitude 8.1 earthquake and a killer tsunami; four people were charged in a plot to blow up New York City's JFK International Airport; a Category 5 hurricane named Dean rolled into the Gulf of Mexico and then slammed the Yucatán Peninsula. It seemed we had read these stories before, perhaps with different statistics or different names.

Among the unwanted, dreaded sequels, the massacre of 32 innocents on the campus of Virginia Polytechnic Institute and State University in April ranked highest.

From the events in 1999 at Columbine High School in Littleton, Colorado, through the decade to these murders in Blacksburg, there had been an ever-growing alarm that this singular form of crime—the school shooting, propelled by rage or a desire for revenge or both—had become part of the American fabric. Columbine was the wake-up call. When Dylan Klebold, 17, and Eric Harris, 18, ran amok—killing 12 kids, a teacher and themselves, and wounding 24—the country's shock was outweighed only by its grief. Columbine was followed, precisely one month later, by an incident at Heritage High School in Conyers, Georgia; by another on March 5, 2001, at Santana High School in Santee, California; by another on January 16, 2002, at the Appalachian School of Law in Grundy, Virginia; by another on September 24, 2003, at Rocori High in Cold Spring, Minnesota; by another on February 3, 2004, at Southwood Middle School in Miami; by another on March 21, 2005, at Red Lake High School in Minnesota; by another on November 8 of that same year at Campbell County High School in Jacksboro, Tennessee. The number of lives claimed in shootings, suicides and murder-suicides in our schools, from the year of Columbine to June '06, totaled more than 250.

And then came the 2006–2007 school year. It began darkly with three fatal incidents at U.S. schools—one in Colorado, one in Wisconsin, one at an Amish schoolhouse in Nickel Mines, Pennsylvania—in the course of a single week. The Amish shootings, in which five girls ages seven to 13 were killed, again captured the nation's attention. President Bush ordered a conference on school violence, but conferences can only do so much: On April 16, Virginia Tech student Cho Seung-Hui took the lives of 33 teachers and students, including his own. The deadliest shooting in the history of our land spawned tearful vigils on campus (right)—and everywhere.

2007

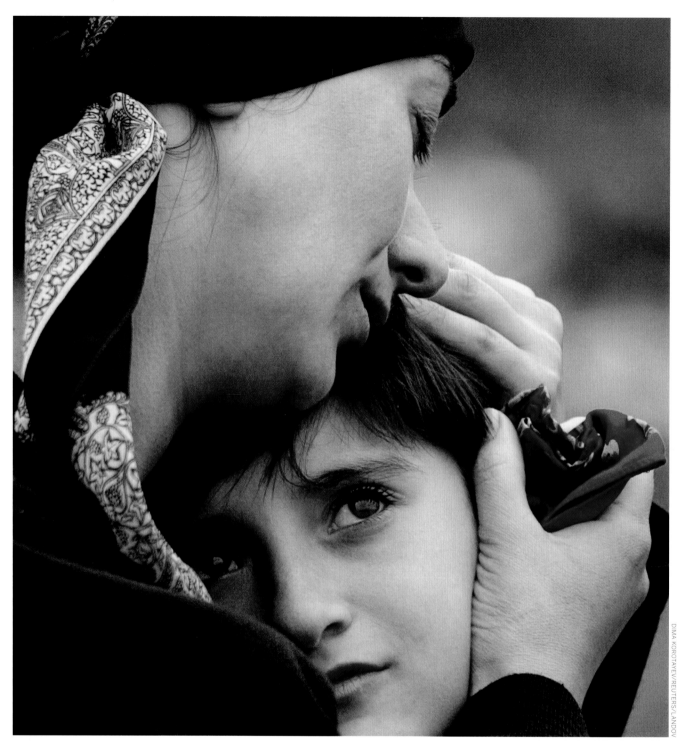

We just discussed the many shootings at American schools throughout the decade, but this plague of violence was by no means exclusive to the U.S. In fact, the most horrific incident in this time frame was the mass murder at School Number One in the Russian town of Beslan. On September 1, 2004, terrorists took more than 1,100 hostages at the school; over two-thirds were children. Their ransom demand was an end to the second Chechen war. The Russians' response was to attack. When the explosions ended, perhaps 400 were dead, including at least 334 hostages, 156 of whom were children. Above: On September 10, a mother comforts her child as they mourn at a Beslan cemetery. Opposite: Another siege, another tragic end. On October 2, 2006, Charles Carl Roberts IV, a 32-year-old milk-truck driver, entered the one-room Amish schoolhouse at Nickel Mines, Pennsylvania, and took 10 young girls hostage. When the police arrived, Roberts threatened a rampage. Marian Fisher, 13, pleaded to be shot first, hoping to buy time for the younger girls. Roberts complied, fatally wounding Fisher and four others, ages seven to 12; he took his own life before police burst in. At top, we see a horse-and-buggy funeral procession heading for Bart Cemetery on October 5. Bottom: In April 2007, Amish children head to their new school-house, built to replace the one razed after the killings. This episode thus comes to a conclusion. Within days, there would be another.

2007

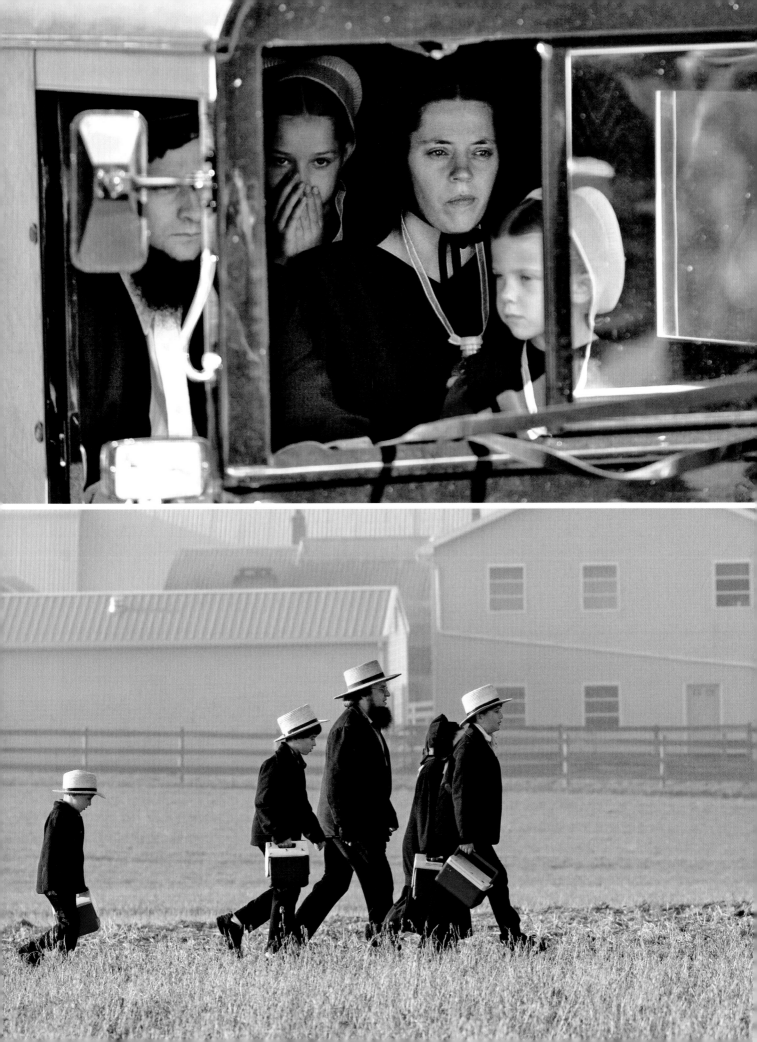

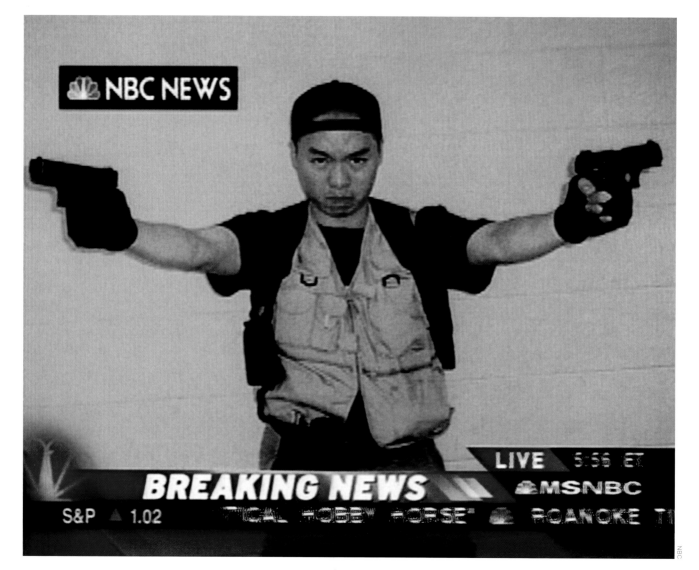

The April 16 massacre at Virginia Tech was carried out in two separate incidents by Cho Seung-Hui, a 23-year-old native of South Korea. Apparently, according to the postmark on a package received on the 18th at NBC television headquarters in New York City, in the two hours between the first shootings at one of the university's dormitories and the more deadly attack at Norris Hall, Cho mailed to the network a rambling account of grievances, plus photos and a video, which included the image above. Opposite, top: Cadets support one another as they mourn near the university's chapel on the night of the shootings. Opposite, bottom: On April 20, Marlena Librescu, widow of Romanian-born Virginia Tech engineering professor Liviu Librescu, weeps during her late husband's burial services in Raanana, Israel. The Holocaust survivor had been gunned down as he heroically defended his students—most of whom he did in fact save from Cho's killing spree.

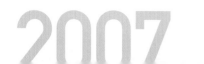

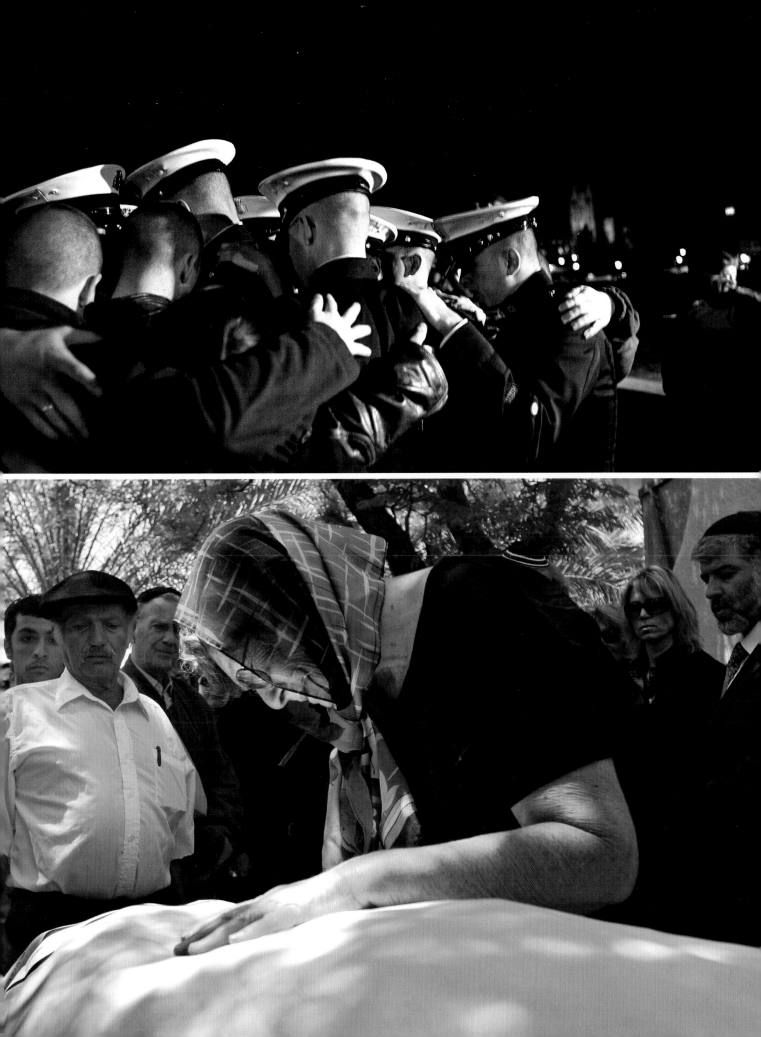

Destruction and construction: In 2007, a bridge collapsed in Minnesota, and a Middle Eastern skyscraper, which wouldn't be officially completed until 2009, became the world's tallest. Back then, they raised one set of questions; later, after the global economy had foundered, they raised another. On August 1, during the evening rush hour, the Interstate 35W bridge that spanned the Mississippi River in downtown Minneapolis crumpled, sending vehicles, tons of concrete and twisted metal crashing into the water. Thirteen were killed, and the bridge failure made an instant issue of the nation's aging infrastructure. Suddenly, states everywhere were testing their bridges and assessing their roads. Only months later, plans to rebuild America slowed to a crawl when the economy tanked. Meantime: What to make of Burj Dubai (a.k.a. the Dubai Tower, opposite)? On July 21, 2007, as the building inched past 1,680 feet in height, Emaar Properties, its developer, quickly issued a statement: "Burj Dubai is now taller than Taipei 101 in Taiwan, which at 508 meters [1,667 feet] has held the tallest-building-in-the-world title since it opened in 2004." Burj Dubai was then at 141 stories, and it had another 20 to go. But by the time it was finished, the principality of Dubai, despite its superwealthy upper crust, was in a thorough economic meltdown worse than America's. What was Burj Dubai a symbol of now?

2007

THE DECADE was glorious for political junkies in America—no fewer than three altogether extraordinary presidential elections—even if the considerable intrigue was marked by unseemly bickering. Enlightened public discourse was all too often outweighed by partisan recrimination, and the Red State–Blue State divide became seemingly etched in stone. Emerging from this political landscape near decade's end was the son of a mixed-race couple who had been raised in a broken home in Hawaii, then had made his way to Harvard, thence to a career as a community organizer and legislator in Chicago. In 2008, he aimed high—and won. When the Founding Fathers conceptualized the United States back in the 1770s, they laid down principles that would make all things possible for Barack Obama, but they could never have imagined him.

The year began with the price of petroleum hitting $100 per barrel for the first time ever; winter heating bills were crushing families, and by the summer, $4 prices at the pump were changing the way Americans drove and bought cars. In February, the Dow plummeted 370 points in one day after a report implied a coming recession in the service sector, an early harbinger of other troubles ahead. In March, more than 50 square miles of ice broke off from Antarctica's Wilkins Ice Shelf, imperiling the rest of the shelf and spurring yet more concern about global warming. In April, the resurgent Taliban tried but failed to assassinate Afghanistan President Hamid Karzai. On May 12, the Wenchuan earthquake, a 7.9 moment-scale event, rocked southwest China, and the toll was terrible, with nearly 70,000 people killed. On June 27, Bill Gates retired as chairman of Microsoft to dedicate his energies to the vast philanthropic efforts of the Bill & Melinda Gates Foundation. In the last week of July, the world's continued instability was front and center as more than 100 were killed and 500 injured in bomb blasts in India, Istanbul and Iraq. In August, American Michael Phelps thrilled sports fans everywhere by winning a record eight gold medals in swimming at the Beijing Olympics. In September, Hurricane Ike, which had already claimed dozens of lives in the Caribbean, made landfall in Texas, and 27 more were killed in the U.S. In October, President Bush signed the Emergency Economic Stabilization Act, which created a $700 billion fund to buy the assets of banks that were crumbling from coast to coast. In November, another series of terrorist attacks by Islamic militants claimed 195 lives in Mumbai, India. In December, Israel struck from the air, then invaded the Gaza Strip; at least 1,300 Palestinians, including hundreds of children, were killed, with more than twice as many injured.

All the while, in the U.S., Barack Obama took his case to the American public and, after upsetting Hillary Clinton to become the Democratic nominee, beat John McCain to be elected the 44th President of the United States. On November 4, as seen here, he celebrated in Chicago's Grant Park, where nearly a quarter of a million supporters gathered to cheer him.

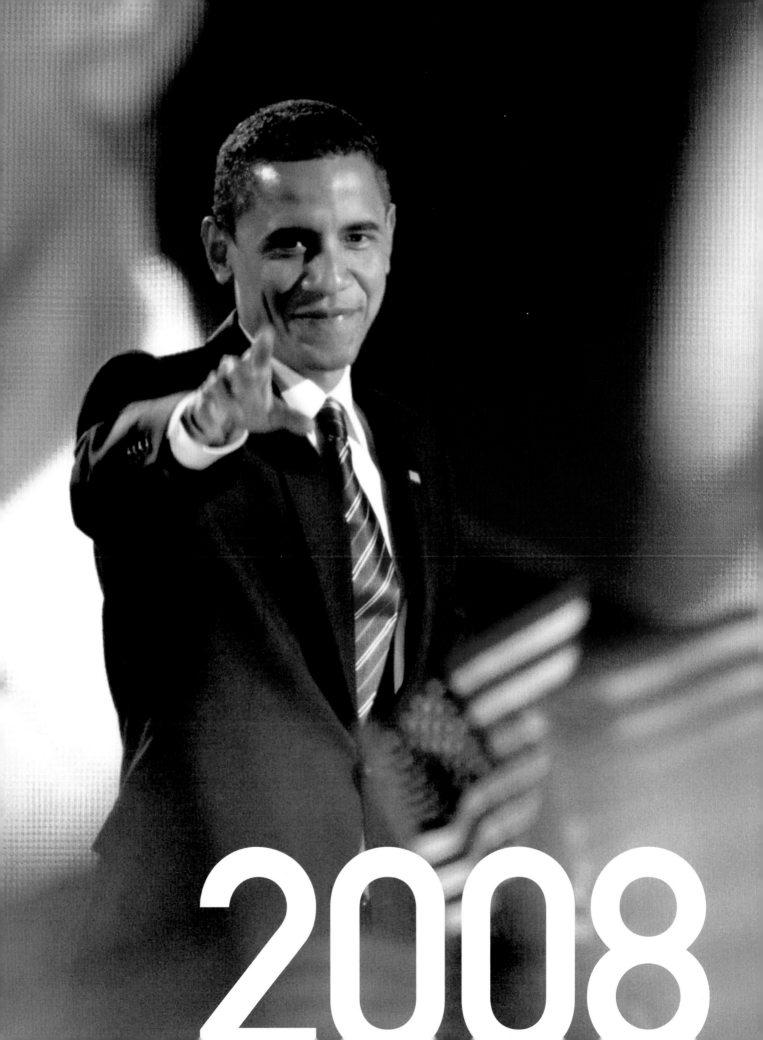

2008

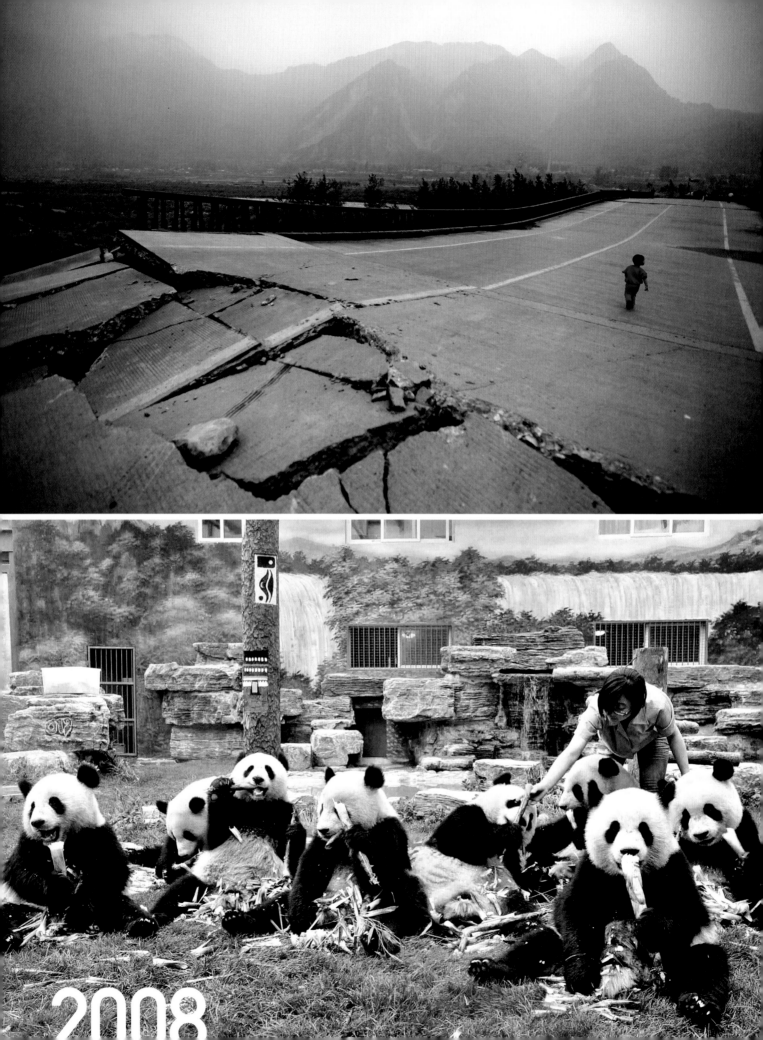

2008

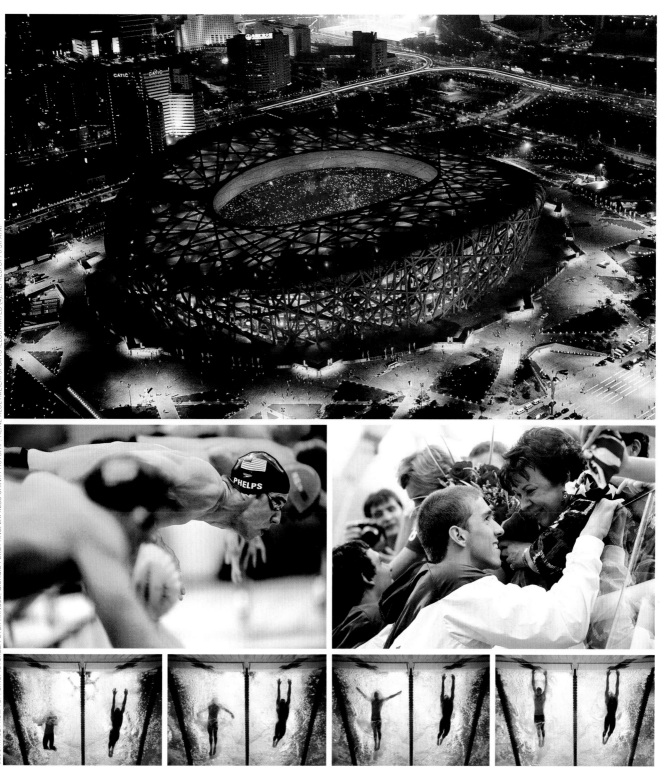

Grief and glory in China: On May 12, the earthquake in Sichuan province caused massive destruction and death, with thousands of lives lost and millions injured or left homeless. Opposite, top: A child walks on a collapsed bridge at Xiaoyutong near Pengzhou two weeks after the quake, while giant pandas relocated to a Beijing refuge gather strength (bottom). Not long after in Beijing, the 2008 Olympic Games open at the National Stadium (top), nicknamed the Bird's Nest, the largest steel structure in the world and an arena of colossal aspiration. The Chinese organizers wanted symbolism and modernism represented in their centerpiece venue, and they got it. Also aspiring and succeeding was Michael Phelps, who at center left is about to hit the pool in the men's 200-meter individual medley final on August 15. He won that and everything else, most narrowly the 100-meter butterfly over Serbia's Milorad Cavic, which Phelps took by the merest measurable margin—1/100th of a second (in the sequence above, Phelps is, believe it or not, the swimmer at left, coming over the top with a half stroke to nip Cavic, who is gliding in). Center right: Having won eight of eight races and relays, Phelps embraces his mom, Debbie.

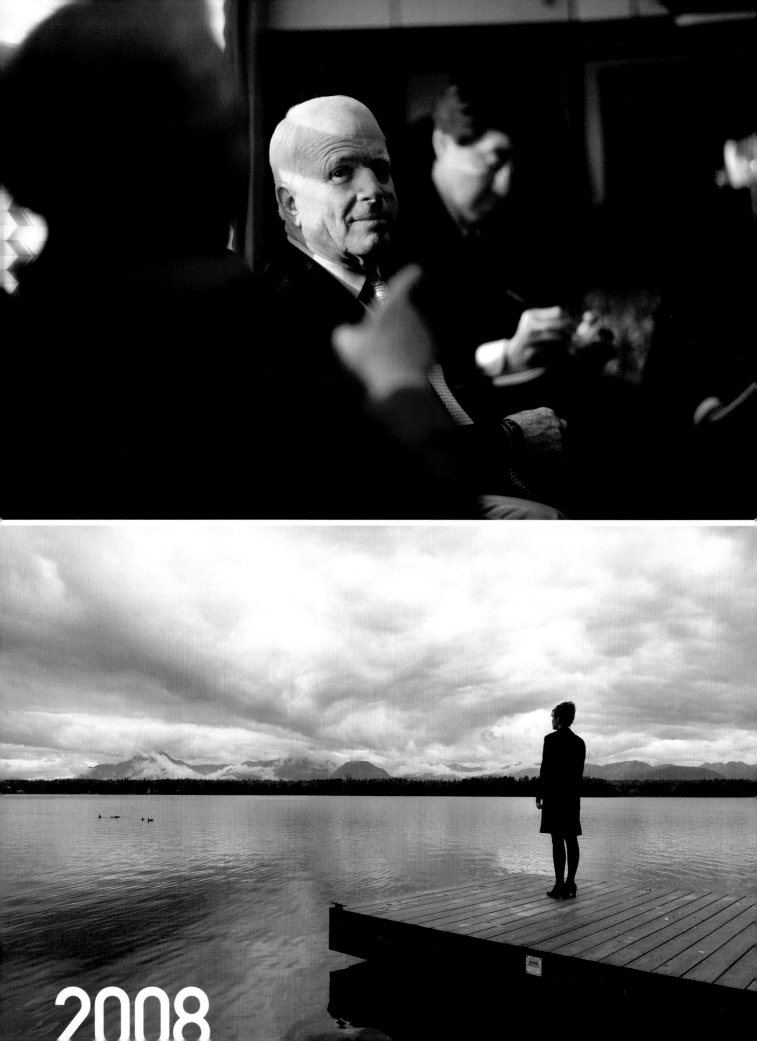

2008

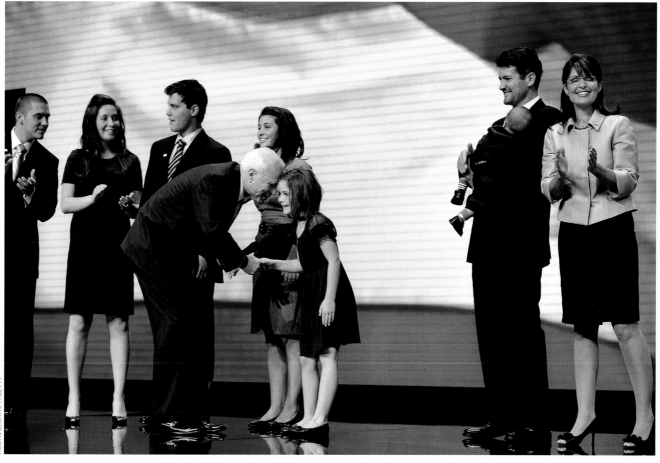

Opposite, top: On March 12, Arizona Senator John McCain is comfortable aboard his campaign bus, the Straight Talk Express, as it rolls through New Hampshire, an influential state whose Republican electorate has always been kind to him. Comfortable at home in Wasilla, Alaska, at this point was that state's governor, Sarah Palin, little known on the national stage, but this was soon destined to change (she is seen on a jetty at the back of her house, looking—it should be said—at the distant mountains, not for invading Russians). Above: On September 3 in St. Paul, after surprise vice presidential nominee Palin has delivered a rousing speech to the Republican National Convention, McCain greets Piper Palin, the youngest daughter of his running mate. Palin will spur an immediate jump in the campaign's poll numbers, but that will quickly settle down as questions arise about her experience—doubts that are not helped by her assertion that she has a grasp of foreign policy because Alaskans can see the ominous Russians from their windows.

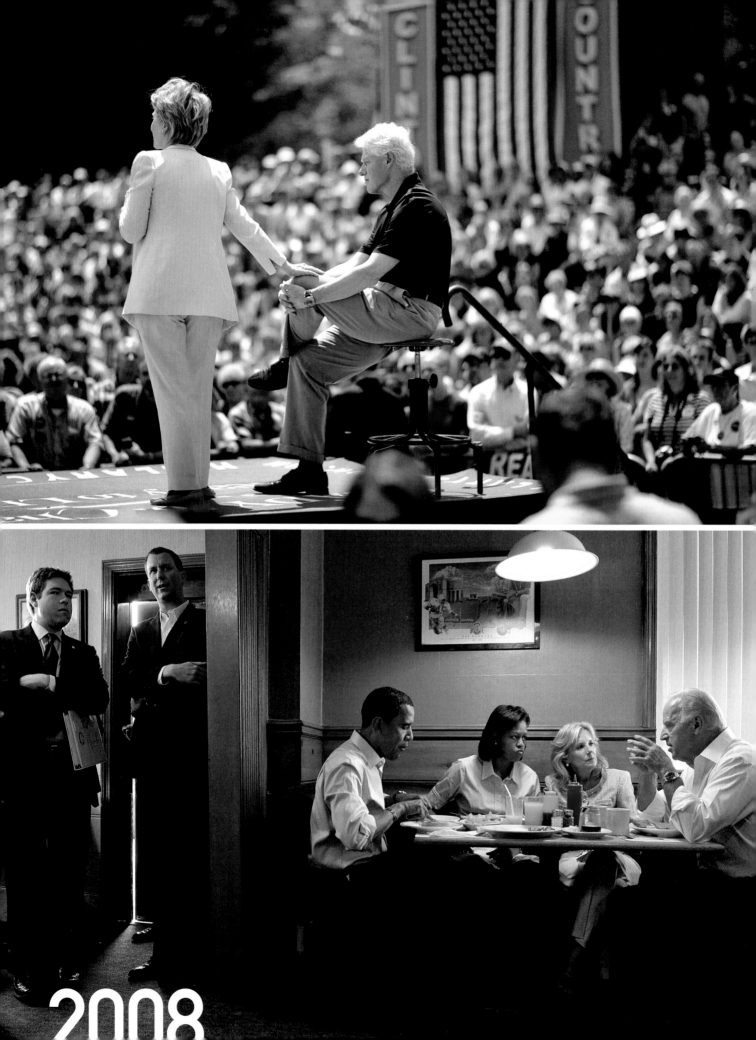

2008

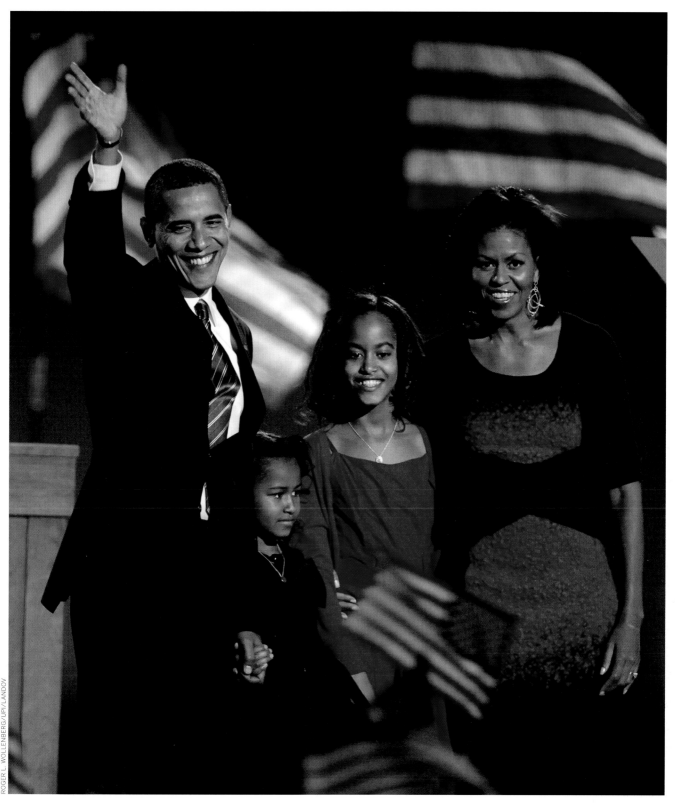

Opposite, top: As presidential candidate Hillary Clinton appears in New Hampshire alongside her husband, Bill, the former U.S. chief executive, she is still the presumptive Democratic nominee. But that will not last, for Barack Obama, a seeming force of nature, cannot be denied in 2008. The party gathered in Denver during the last week of August to formally anoint Obama as its choice and Delaware Senator Joe Biden as his running mate; after the tents have been struck in Colorado, Barack and Michelle Obama breakfast with Joe and his wife, Dr. Jill Biden (opposite, bottom), at the Yankee Kitchen Restaurant in Boardman, Ohio, on August 30. Two months of ceaseless campaigning lie ahead of them, then victory. Above: On the night of the historic day—November 4, 2008—the President-elect and his family greet their friends in Chicago's Grant Park.

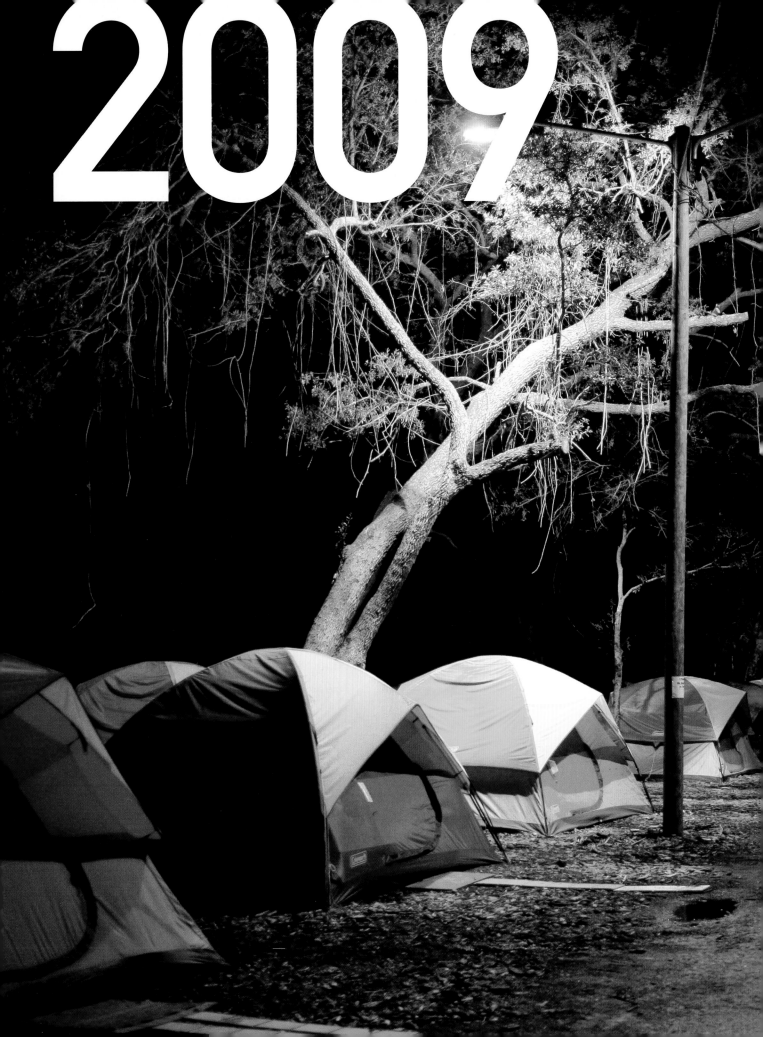

2009

WHEN BILL CLINTON first ran for President in 1992, his campaign strategist James Carville tried to focus the troops on the salient issue with a line that would become famous in political lore: "It's the economy, stupid." Never would that phrase be more apt when parsing the American mind-set than in 2009. The election was done; Obama was sworn in (seen on the pages that immediately follow); there was strife around the world; military activity would soon escalate in Afghanistan; North Korea and Iran continued their posturing and provocation . . . But throughout the land, foreclosures and job losses dominated the discussion. The economy was in tatters; there hadn't been a situation like this since the Great Depression. Crimes, misdemeanors and plain old mistakes of the recent, greedy past were uncovered daily, but while these revelations stoked national anger, they didn't really matter. The one question that did count was: What can be done? As modern-day Hoovervilles, featuring lightweight, miracle-fiber dome tents instead of the canvas models of the 1930s, began popping up in places like Sacramento and Phoenix and Nashville and (seen here, in June) Pinellas Park, Florida, all that anyone cared about was: What can be done?

How can I get my home back?

Where can I find work?

There certainly was other news in 2009. The pitched battle over health-care reform was a major topic, and periodically the American public paused to mourn the passing of a truly major figure—Farrah Fawcett, Walter Cronkite, Ted Kennedy and, stunningly, Michael Jackson at age 50. But overriding all was the pain caused by the severe economic downturn and concern about what, if anything, could be done to alleviate the suffering.

When the housing bubble burst, it burst loudly. In 2008, there had been more than 3.1 million home foreclosure filings in the U.S., and 2009 looked to be on track to eclipse that astonishing figure. In 2008, American companies had eliminated 1.9 million jobs, and in 2009, the trend continued, with the unemployment rate edging toward double digits—and, in some places, breaking that chilling benchmark. Banks that held subprime mortgages on woefully overvalued properties began to fail, and federal financial institutions required shoring up; the spiral continued. The Obama administration's response was multifold, with its centerpiece being a historic stimulus package—some $790 billion in public monies overall, poured forth in hopes of jumpstarting the economy—the effectiveness of which will only be known, for certain, in the long term.

The country did not technically enter a depression, but for many the difference between *depression* and *recession* seemed to be one of semantics. Furthermore, the failure of global financial markets proved not only how interdependent the world had become but how difficult the climb back from danger would be: Where would support come from if all were ailing?

This tumultuous decade of change ended with yet another reckoning and yet another forced reappraisal of the world we had thought we lived in against the world as it actually was.

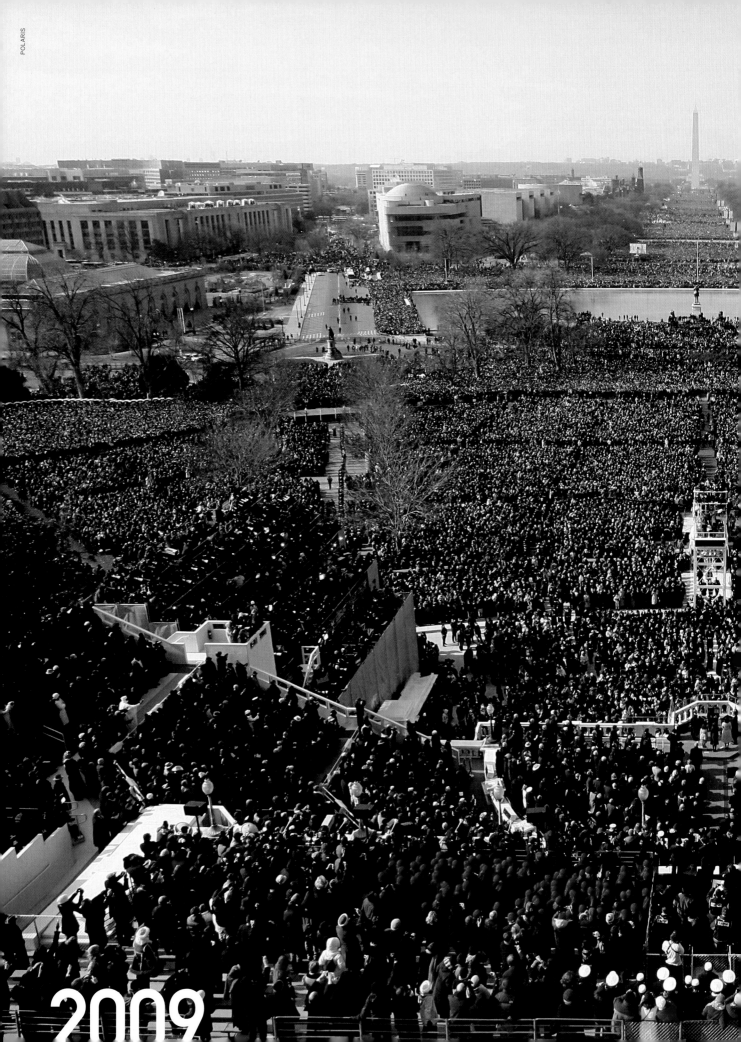

2009

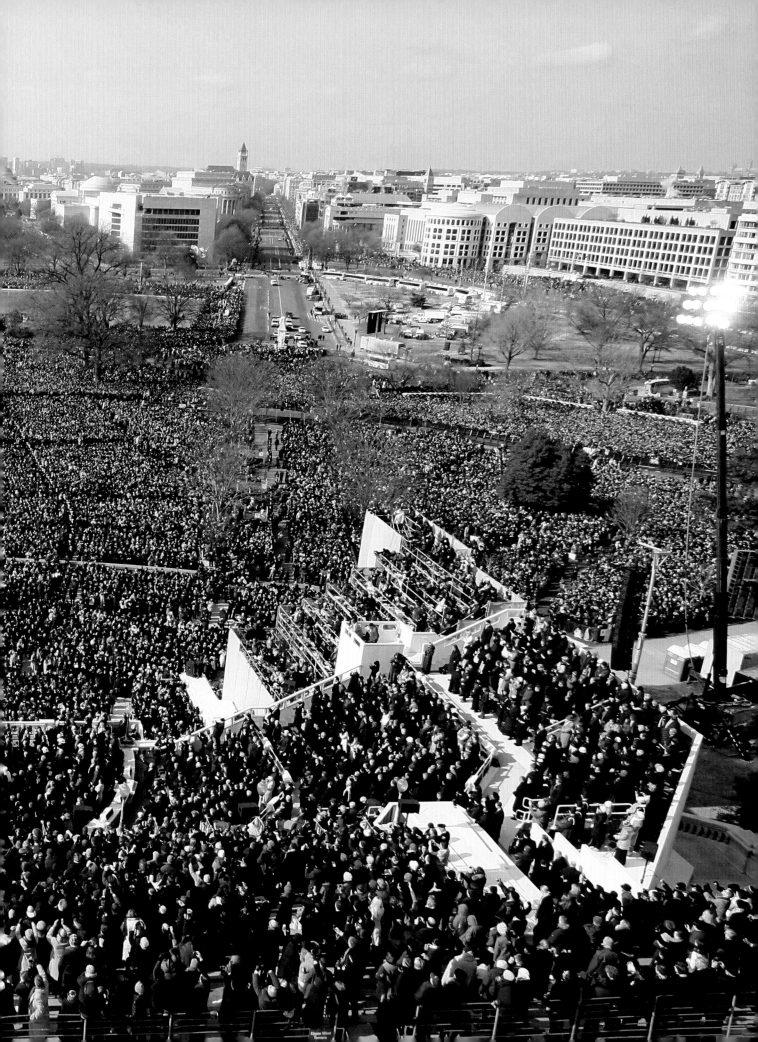

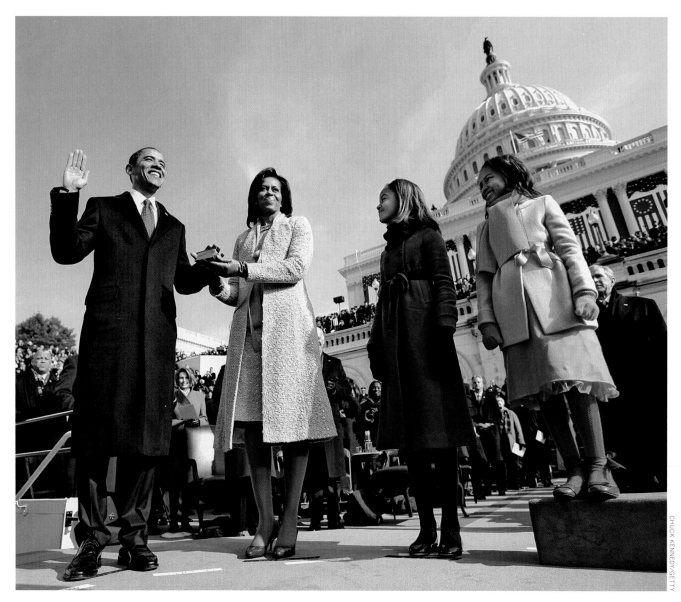

Did Barack Obama really know, on January 20, what he was getting himself into as he solemnly swore to take on the job? Whether yes or no, that was quite a day in the capital as some two million people congregated in Washington (on the previous spread) to celebrate the historic occasion. At noon, Obama, by law, becomes the 44th President of the United States of America, and five minutes later (the ceremonies are running a tad late), he places his hand on the Bible held by his wife (above)—a Bible used by Abraham Lincoln when taking the same oath. Looking on as U.S. Supreme Court Chief Justice John Roberts presides are the Obamas' daughters, Malia (left) and Sasha. When the formalities are over, Obama delivers a strong and somewhat stern inaugural address calling for fortitude in difficult times. Just how difficult soon becomes clear: It's not only the housing market and Lehman Brothers and AIG and the Detroit automakers and the climbing unemployment rate—it seems to be everything. Opposite, top: Treasury Secretary Timothy Geithner (center) listens as Obama unveils his administration's plan to help homeowners facing foreclosure during a speech at Dobson High School in Mesa, Arizona, on February 18. Opposite, bottom: Six days later, on a bitterly cold morning in New York City, a job fair at a midtown hotel attracts thousands of unemployed, and the line snakes down the block and back.

2009

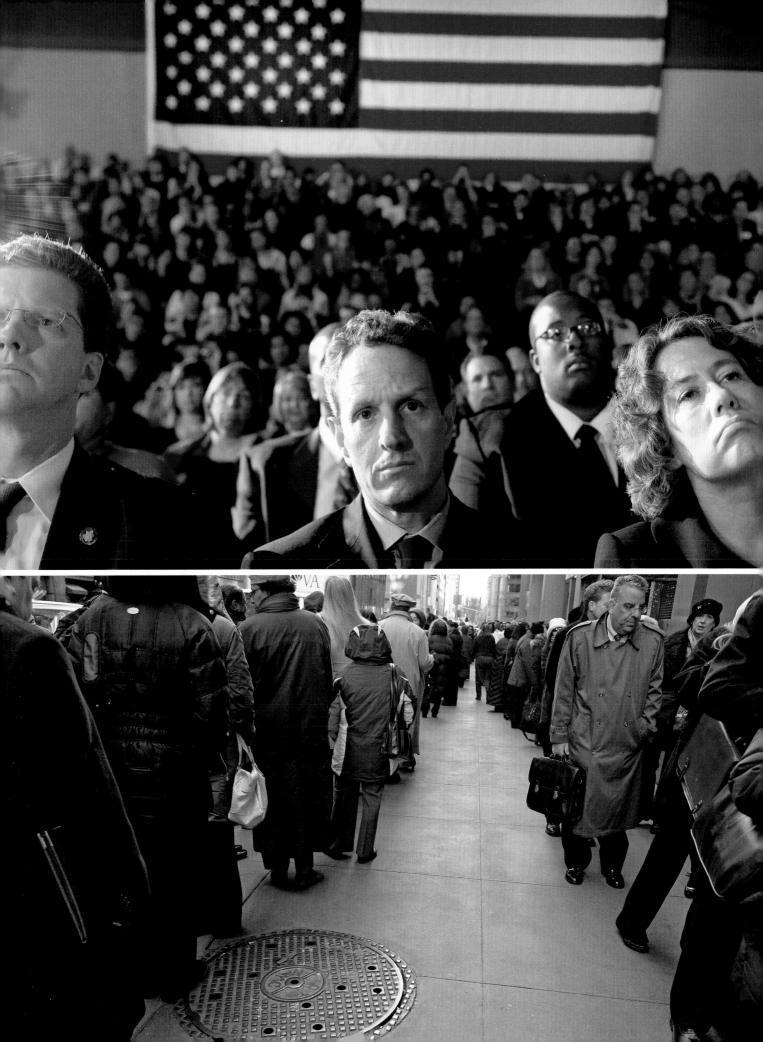

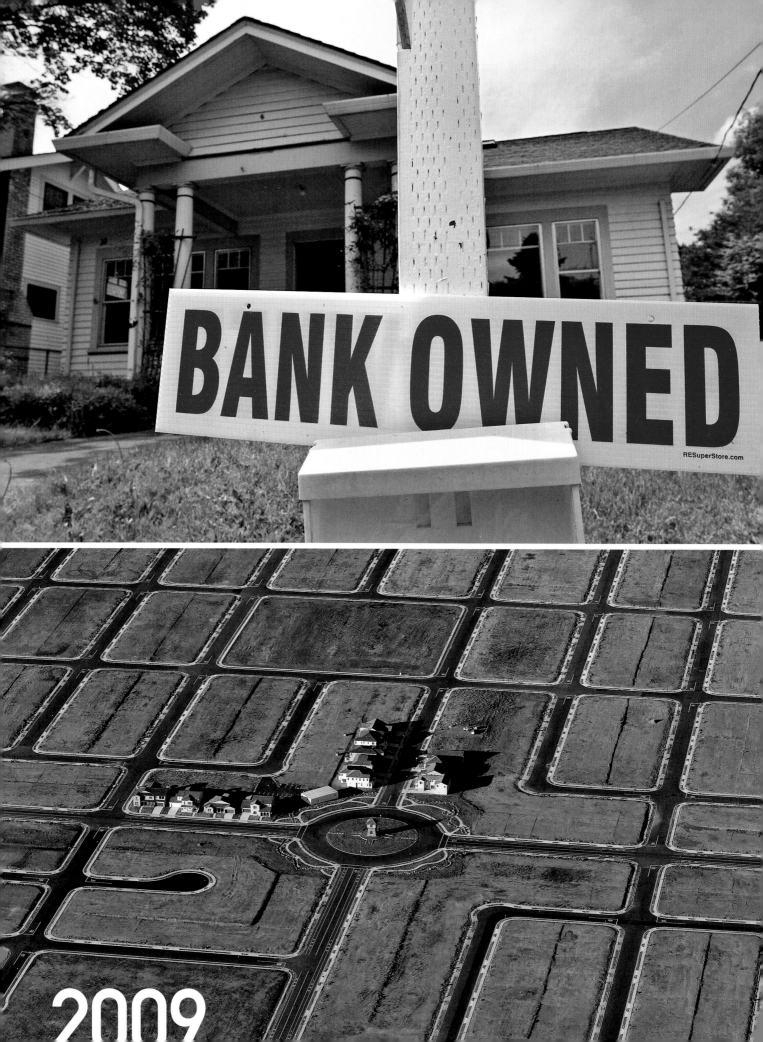

BANK OWNED

RESuperStore.com

2009

Scenes from a recession, counterclockwise from opposite, top: On May 26, the sign in front of the house at 2335 NE 42nd Street in Portland, Oregon, says it all. Foreclosures spread like wildfire from coast to coast, and no societal sector or geographical region is spared in this downturn. In Rio Vista, California, where the city's general fund is itself experiencing an $816,000 shortfall, model homes sit vacant in the center of a planned 750-home development, construction of which was halted in late 2008. As a way to stimulate car sales, the Cash for Clunkers program proved massively popular as Americans rushed to swap their old gas guzzlers (like this one pictured on August 5 in Temple Hills, Maryland) for new automobiles—with the government offering rebates of as much as $4,500. In Cape Coral, Florida, on March 26, Marc Joseph, the owner of Foreclosure Tours R Us realty, uses a boat and a map to show prospective buyers what's available below market value, which constitutes a bounteous supply.

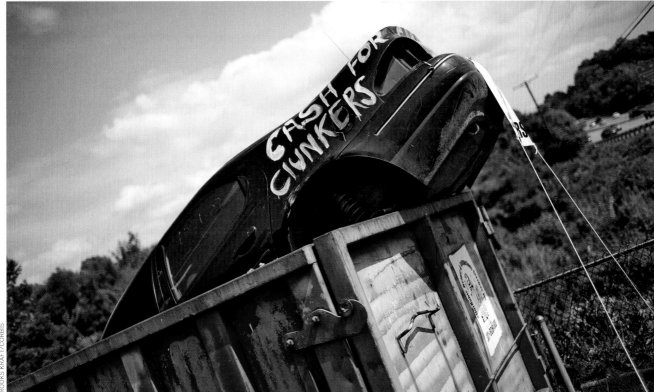

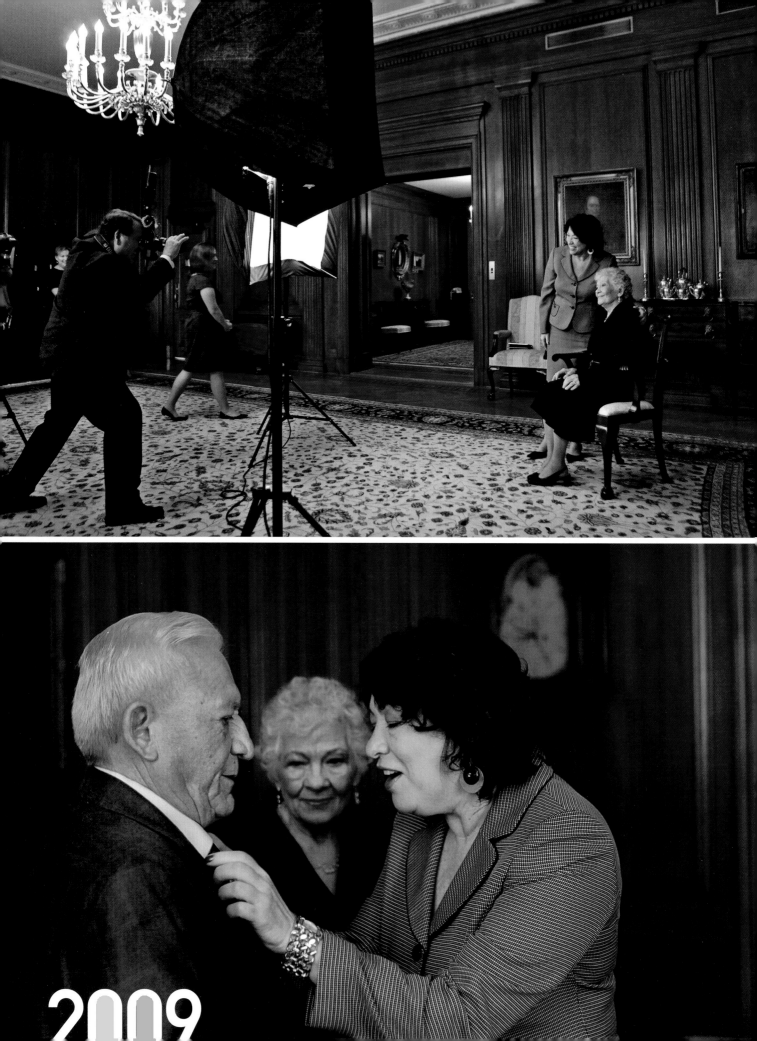

2009

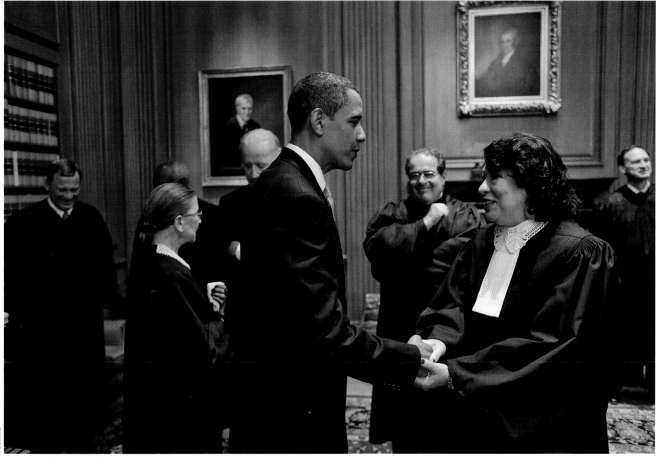

The new President's first nomination to the Supreme Court was sure to cause furor, and Barack Obama's pick of Sonia Sotomayor to replace retiring David Souter certainly did. But the Democrats were now in charge of all committees and both houses of Congress, and at the end of the day, nothing was going to stop this woman from the Bronx from becoming the Court's 111th justice—its third female and very first Hispanic. It's interesting to note that during her rise through the judicial system, she had been nominated to the U.S. Court of Appeals for the 2nd Circuit by Bill Clinton—not surprising—but six years earlier, in a less contentious age seemingly long, long ago, she had been nominated as a judge of the U.S. District Court for the Southern District of New York by President George H.W. Bush. Opposite, top: On September 8, the Supreme Court's newest member poses just before her investiture ceremony with her burstingly proud mother, Celina, who, later, watches as Sonia straightens her stepfather's tie before a reception in her honor (bottom). Above: The President congratulates his choice. To the left is Ruth Bader Ginsburg, the second woman to be named a justice (Sandra Day O'Connor was the first), and in the background between the President and the new justice is a smiling Antonin Scalia, who is no doubt anticipating some entertaining debates with Sotomayor.

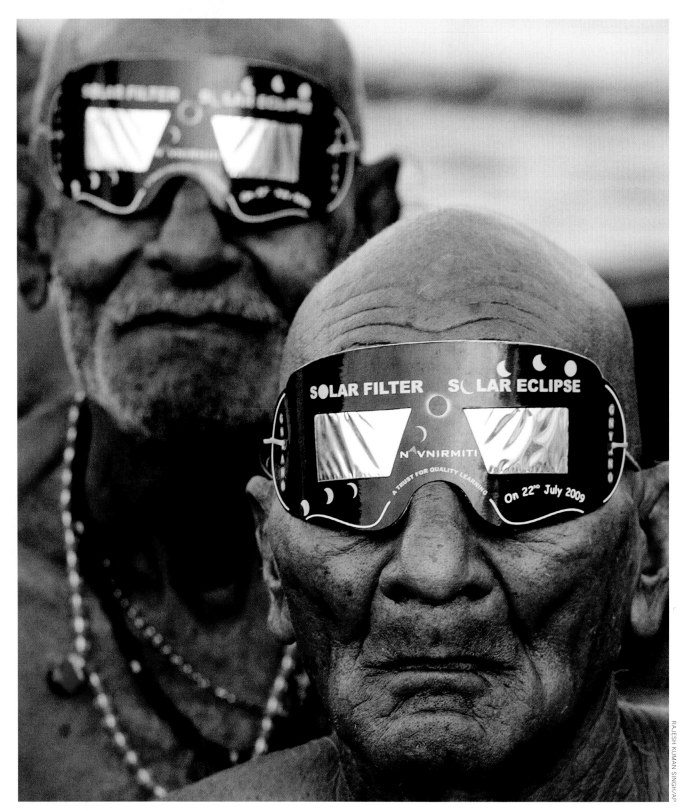

The longest total solar eclipse of the decade—and therefore of the century and even the millennium thus far, not to be eclipsed, please pardon the pun, until June 2132—was quite a spectacle in Asia. Occurring on the 22nd of July, it lasted no less than six minutes and 39 seconds and entertained millions of folks in India, Nepal, China, Japan and other places as well. It seems to offer a nice way to close the curtain on this decade before we revisit, on the pages that follow, friends who were lost along the way. We have traveled from the fireworks and Y2K concerns of late 1999 to a world transformed—transformed, but still impressed by the natural order and what it all might mean. Above: Sadhus, or Hindu holy men, watch the eclipse in Allahabad, India, through specially designed glasses. Opposite: A party gathers along the banks of the Ganges River in the Indian city of Varanasi.

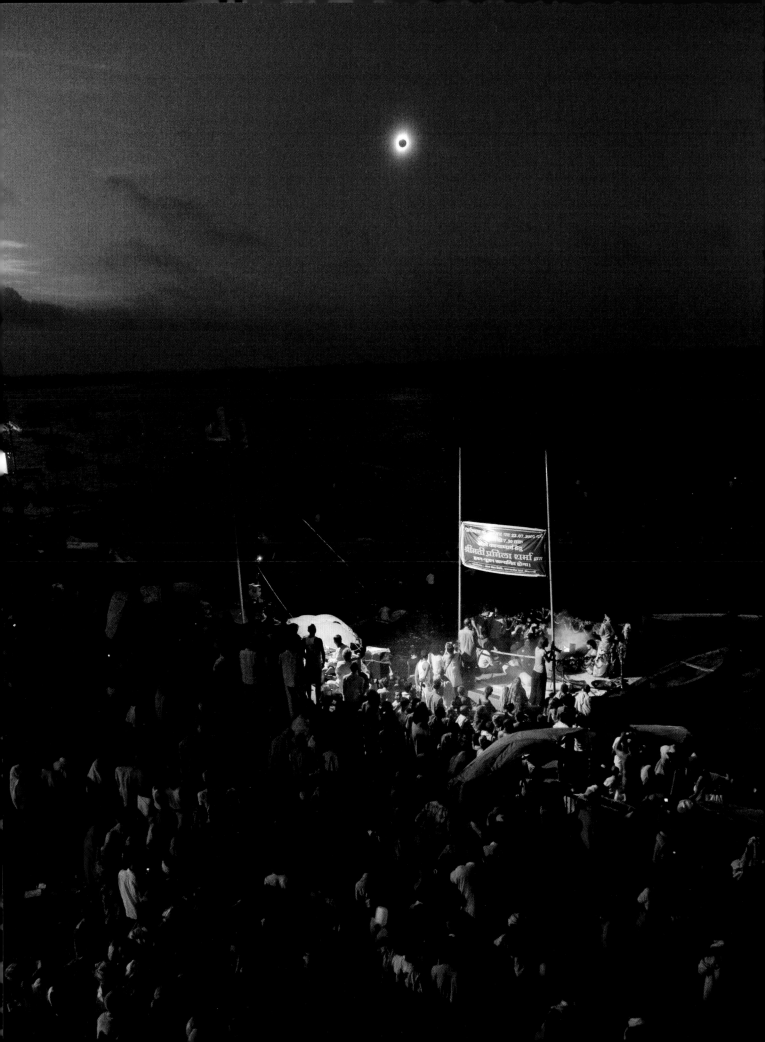

FAREWELL

MICHAEL EVANS/ZUMA

Ronald Reagan | 1911–2004
40th President of the
United States
*"I know in my heart that
man is good. That what is
right will always eventu-
ally triumph. And there's
purpose and worth to each
and every life."*

Pope John Paul II (né Karol Wojtyla) | 1920–2005
Polish-born leader of the Roman Catholic Church
"Radical changes in world politics leave America with a heightened responsibility to be, for the world, an example of a genuinely free, democratic, just and humane society."

Gerald Ford | 1913–2006
38th President of the United States
"Our constitution works. Our great republic is a government of laws, not of men. Here the people rule."

Ted Kennedy | 1932–2009
U.S. senator from Massachusetts, 1962–2009
"For all those whose cares have been our concern, the work goes on, the cause endures, the hope still lives, and the dream shall never die."

Rosa Parks | 1913–2005
American civil rights pioneer
"When he saw me still sitting, he asked if I was going to stand up, and I said, 'No, I'm not.' And he said, 'Well, if you don't stand up, I'm going to have to call the police and have you arrested.' I said, 'You may do that.'"

Walter Cronkite | 1916–2009
American network news anchor
"And that's the way it is."

William F. Buckley Jr. | 1925–2008
American writer, magazine editor and political commentator
"I'd rather entrust the government of the United States to the first 400 people listed in the Boston telephone directory than to the faculty of Harvard University."

Peter Jennings | 1938–2005
Canadian-born American network news anchor
"Have a sense of humor about life—you will need it. And be courteous."

Tim Russert | 1950–2008
American television journalist
"The primary responsibility of the media is accountability of government, whether it's about lying under oath, which upsets Democrats, or the mismanagement of responding to a hurricane, which happens to upset Republicans."

FROM LEFT: PETER STACKPOLE, NBCU PHOTO BANK/AP; MICHAEL OCHS ARCHIVE/GETTY

Bob Hope | 1903–2003
British-born American comedian
and movie star
*"I do benefits for all religions. I'd hate
to blow the hereafter on a technicality."*

Milton Berle | 1908–2002
American comedian and television star
"I live to laugh, and I laugh to live."

Johnny Carson | 1925–2005
American comedian and talk show host
*"People will pay more to be entertained
than educated."*

FROM LEFT: BETTMANN/CORBIS; JIM DEMETROPOULOS/RETNA/CORBIS

Richard Pryor | 1940–2005
American comedian and actor
"Everyone carries around his own monsters."

George Carlin | 1937–2008
American comedian
"Always do whatever's next."

Julia Child | 1912–2004
American cookbook author and television chef
"Life itself is the proper binge."

Charles M. Schulz | 1922–2000
American cartoonist and creator of "Peanuts"
"Life is like an ice cream cone: You have to lick it one day at a time."

Fred Rogers | 1928–2003
American educator and children's television host
*"Knowing that we can be loved exactly as we are gives us all
the best opportunity for growing into the healthiest of people."*

Bob Keeshan | 1927–2004
American actor, famously known as TV's Captain Kangaroo
"Play is the work of children. It's very serious stuff."

Seattle Slew | 1974–2002
American Triple Crown–winning thoroughbred
"He wanted to be a racehorse. Even the last couple of years, they were still riding him around. That's what kept him happy. That's what kept him going."
—Doug Peterson, trainer

Barbaro | 2003–2007
American Kentucky Derby–winning thoroughbred
"If tears could heal a wound, Barbaro would be healed by now."
—Edgar Prado, jockey

Keiko | 1976(?)–2003
North Atlantic–born orca and star of the *Free Willy* movies
"Keiko was not one of our kind but nonetheless was still one of us."
—Thomas Chatterton, veterinary chaplain

Ted Williams | 1918–2002
American baseball star
*"A man has to have goals—
for a day, for a lifetime—
and that was mine, to have
people say, 'There goes Ted
Williams, the greatest hitter
who ever lived.'"*

Sam Snead | 1912–2002
American golf champion
*"Correct one fault at a time.
Concentrate on the one fault
you want to overcome."*

119

DOZIER MOBLEY/GETTY

Dale Earnhardt | 1951–2001
American race-car driver
"The winner ain't the one with the fastest car, it's the one who refuses to lose."

FROM LEFT: POPPERFOTO/GETTY; THOMAS D. MCAVOY

Sir Edmund Hillary | 1919–2008
New Zealand mountaineer and conqueror of Mount Everest
"You don't have to be a fantastic hero to do certain things—to compete. You can be just an ordinary chap, sufficiently motivated."

Althea Gibson | 1927–2003
American tennis champion and professional golfer
"Shaking hands with the Queen of England was a long way from being forced to sit in the colored section of the bus going into downtown Wilmington, North Carolina."

Sammy Baugh | 1914–2008
American football star
"I reckon I can throw a little."

Johnny Unitas | 1933–2002
American football star
"There is a difference between conceit and confidence. Conceit is bragging about yourself. Confidence means you believe you can get the job done."

Katharine Hepburn | 1907–2003
American actress
"I never lose sight of the fact that just being is fun."

Marlon Brando | 1924–2004
American actor
"An actor's a guy who if you ain't talking about him ain't listening."

Gregory Peck | 1916–2003
American actor and humanitarian
"I don't lecture and I don't grind any axes. I just want to entertain."

Paul Newman | 1925–2008
American actor and philanthropist
"I picture my epitaph: 'Here lies Paul Newman, who died a failure because his eyes turned brown.'"

Charlton Heston | 1923–2008
American actor, civil rights activist and National Rifle Association president
"It's been quite a ride. I loved every minute of it."

Christopher Reeve | 1952–2004
American actor
"A hero is an ordinary individual who finds the strength to persevere and endure in spite of overwhelming obstacles."

Heath Ledger | 1979–2008
Australian actor
"I'm not good at future planning. I don't plan at all. I don't know what I'm doing tomorrow . . . I completely live in the now, not in the past, not in the future."

Farrah Fawcett | 1947–2009
American actress
"The reason that the all-American boy prefers beauty to brains is that he can see better than he can think."

Patrick Swayze | 1952–2009
American actor
"Good-looking people turn me off. Myself included."

Gordon Parks | 1912–2006
American photographer, writer, filmmaker, painter, musician
"I suffered evils but without allowing them to rob me of the freedom to expand."

Richard Avedon | 1923–2004
American fashion photographer and portraitist
"If a day goes by without my doing something related to photography, it's as though I've neglected something essential to my existence, as though I had forgotten to wake up."

John Updike | 1932–2009
American novelist and man of letters
"Creativity is merely a plus name for regular activity. Any activity becomes creative when the doer cares about doing it right, or better."

Arthur Miller | 1915–2005
American playwright
"I think it's a mistake to ever look for hope outside of one's self."

Norman Mailer | 1923–2007
American novelist and journalist
"Writing books is the closest men ever come to childbearing."

Saul Bellow | 1915–2005
Canadian-born American novelist
"A man is only as good as what he loves."

Kurt Vonnegut | 1922–2007
American novelist
"Be careful what you pretend to be because you are what you pretend to be."

George Harrison | 1943–2001
English rock 'n' roll singer and guitarist in the Beatles
"I think people who can truly live a life in music are telling the world, 'You can have my love, you can have my smiles. Forget the bad parts, you don't need them. Just take the music, the goodness, because it's the very best, and it's the part I give.'"

Rosemary Clooney | 1928–2002
American vocalist and actress
"I'll keep working as long as I live because singing has taken on the feeling of joy that I had when I started, when my only responsibility was to sing well."

James Brown | 1933–2006
American soul singer
"When I'm onstage, I'm trying to do one thing: bring people joy. Just like church does. People don't go to church to find trouble, they go there to lose it."

Luciano Pavarotti | 1935–2007
Italian operatic tenor
"For me, music making is the most joyful activity possible, the most perfect expression of any emotion."

Bo Diddley | 1928–2008
American rock 'n' roll pioneer
"I opened the door for a lot of people, and they just ran through and left me holding the knob."

Ray Charles | 1930–2004
American soul singer and pianist
"I was born with music inside me. Music was one of my parts. Like my ribs, my kidneys, my liver, my heart. Like my blood . . . It was a necessity for me—like food or water."

Mary Travers | 1936–2009
American folksinger in the trio Peter, Paul and Mary
"People say to us, 'Oh, I grew up with your music,' and we often say, sotto voce, 'So did we.'"

June Carter Cash | 1929–2003
Johnny Cash | 1932–2003
American country singers
"He's just like my father that way—my father just adored my mother and let her do whatever she wanted. John's like that. He's a very rare man, a very good man, and I've had a good life with him."
—June
"Because you're mine I walk the line." —Johnny

Michael Jackson | 1958–2009
American pop and R&B
singer-songwriter
*"If you enter this world knowing you are
loved and you leave this world knowing
the same, then everything that happens
in between can be dealt with."*

2000-